CREATING THE NORTH AMERICAN LANDSCAPE

Gregory Conniff

Edward K. Muller

David Schuyler

CONSULTING EDITORS

George F. Thompson

SERIES FOUNDER AND DIRECTOR

Published in cooperation with the Center for American Places, Santa Fe, New Mexico, and Harrisonburg, Virginia

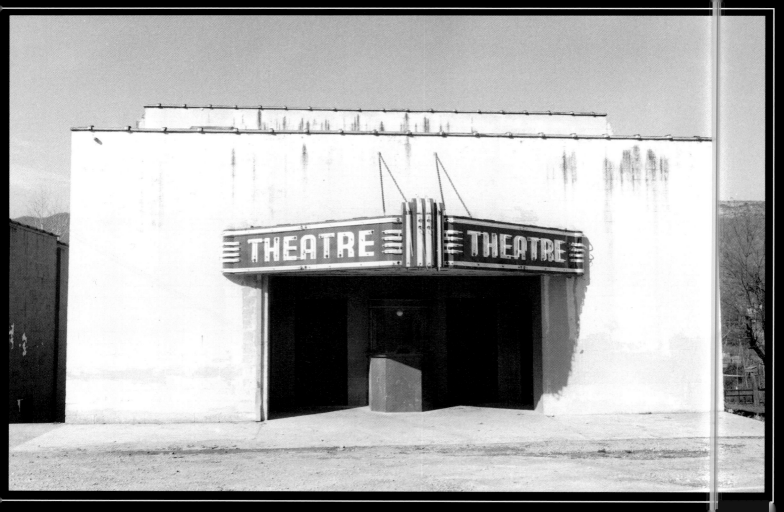

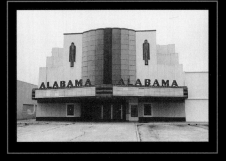

American society's refusal to crack beneath the dire load of the Depression owed something to an imaginative wealth that, via the

movies, solace asses with debonair images of luxury. Images were in a way superior to the real thing, if we believed those Hollywood

comedies in which the rich were often foolish and not infrequently miserable: they suffered from ulcers, financial reversals, and the dis-

contents of excessive propriety; they were hostages to their fortunes, and prey to complications from which ordinary men were exempt.

Our hearts went out to them, and their happy endings became ours. Movies, mediating between Myrna Loy and the twelve-dollar-a-

week shopgirl, spun a web of trust, of sympathetic connection, like the bonds of patriotism and brand-name loyalty.

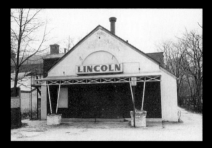

CONTENTS

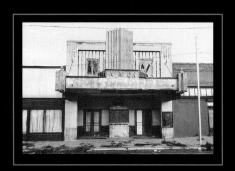

Disappearance preserves some presence, always waning into loss. One anodyne is to collect things. Willingly and unwillingly, I have taken responsibility for preserving things that are passing from the world. I have collected things that are not preservable in primary form, things I cannot own or acquire, which are nevertheless part of me. The testimony I have collected will have to stand in place of the void loss is creating. The small-town and neighborhood movie theater is almost gone.

What do we see in the movie theaters we remember, the single-screen theaters that dominated the Main Streets of rural America and the small, inner-city neighborhood theaters of the burgeoning nation? The theaters were there. They were part of the landscape of America. They were part of the lineup of prominence. They were next to the barbershops, the drugstores, the clothing stores, the five-and-tens—character traits of Main Street. And when they were no longer part of American life, they were still part of the built environment, the landscape of the street: Closed, Thankyou, was on the marquee. And then they began to disappear.

The question why can be answered. The small-town theater contributed only a modest share of Hollywood's profits, as Robert Sklar reveals in his introductory essay, and decentralization changed our way of life. But we must account for the emotional significance of the theaters that are gone. When we look at the present images we see some part of ourselves that facts and figures do not explain.

Other commentaries in this book counter the dispassionate economic reading of these ruins. Larry McMurtry sees the blank stare of the closed theater in town after town with a sense—which goes to the quick—of the deprivation it represents. Peter Bogdanovich, writing here of a childhood in some sense formed by

moviegoing, sees the small movie theater as representative of a time of cultural innocence. Andrew Sarris remembers the theaters of his childhood as places where people of every background came together for an experience that took them out of their own world. Molly Haskell reads the movies of her teenage years as texts for change and growth and the closed theaters as ghosts of the community. The spatial environment in which the small theater had thrived was left behind, as Chester Liebs points out, and the community that had been served by that environment inherited its real estate.

We are to be concerned with two things here. There is the building, and there is the experience the building housed. John Hollander's litany of witness, part of a longer poem that names his movie theater landmarks one by one, gives voice to this book's images. The movies themselves are still viewable in one form or another, but the American landscape has changed. The photographs here, and the lists of demolitions and conversions, rehearse a loss that is actual. All the same, they recall us to that which lives, rich and eloquent, inside us.

I realize that the photographs in this book may not represent the current status of the theater shown, and I apologize to any persons not acknowledged in this book who have saved and restored old theaters. There are areas not accounted for in these pages. Some of America's great cities are not represented, as well as many regions of this country where the small-town theater was an important part of life. I regret the ones I've missed.

I would like to thank George F. Thompson, president of the Center for American Places, for recognizing the importance of this project and for bringing it to the Johns Hopkins University Press for publication. With a sharp eye and a sure sense of purpose, George executed the difficult tasks of selecting the images from a large number of photographs that varied in approach and content and of ordering them to create the book. Thanks also to Randall Jones, from the same office, and to Julie McCarthy, at the Johns Hopkins University Press, for helping to organize the many logistical aspects of publishing these photographs.

For introducing this project to Furthermore . . . , I want to thank Cynthia Ryan and Linda Gillies. And my thanks to Furthermore . . . for their interest in and support of this book.

I thank the authors of the book's texts—Robert Sklar for providing the introduction; Peter Bogdanovich, Andrew Sarris, Molly Haskell, and Chester H. Liebs for writing about their particular experiences and understandings; and John Updike, Larry McMurtry, and John Hollander for allowing me to use excerpts from previously published texts.

For their help in finding movie theaters and for providing information about theaters, I would like to thank the late Jim Marcus and his wife, Martha, of Cleveland, Ohio, who introduced me to the *Film Daily Yearbook*, which effectively changed the direction of this project; Irma Jean Bowman, of Remington,

ACKNOWLEDGMENTS

Indiana; Spike Gaffney, of Cincinnati, Ohio; Leon Irwin, of New Orleans, Louisiana; Marty Mays, of Houston, Texas; and all those people in barbershops, post offices, and chambers of commerce across the country who provided me with so much information about their towns and were so generous with their time.

For their evaluation of this project and their suggestions throughout its development, I thank Peter Andersen, David Godine, Bonnie Gordon, Thomas Hauser, Lewis Koch, Nathan Lyons, Judy Natal, John Pfahl, Jonathan Rosenbaum, Elliot Schneider, and Charles Stainback; with particular thanks to Alan Trachtenberg, who generously gave considerable time and thought to the implications of the photographs in the very important context of the way we see.

For their part in getting the photographs ready for publication, I appreciate the help of Bruce Gilden and of everyone at Light Work, Syracuse, New York—Jeffrey Hoone, Gary Hesse, Mary Lee Hodgens, and John Freyer.

I am very grateful to Robert Monge and William Leman of Monge Property Management Company, Pekin, Illinois, who gave me unlimited access to the site of the Pekin Theater during its demolition in 1987. Without their cooperation an important part of this project would not have been realized. Maxine Maloney, from Mr. Monge's office, was very helpful in keeping me informed about the timetable for the theater's demolition. Leona Aque Dunn provided me with valuable background information about the Pekin, including a scrapbook she had kept while working at the theater's candy counter during her high school years. Jerry and Irene of the Arlington Restaurant provided great cooking and made me feel welcome.

For allowing me to photograph within theaters converted to other uses, and for assistance once inside, I am grateful to Don Garecht, at Time for Tots, Philadelphia, Pennsylvania; Burton Cleveland and Travis Breaux, at Bookstop, Houston, Texas; Corey Baxter, at Summit Community Bank, Fort Worth, Texas; William Christian, at Christian and Associates, Anniston, Alabama; Diana Spencer, at Brasserie Deitrich's, Louisville, Kentucky; Sharon Schweikhard and James Wojcik, at Lovejoy Pool, Buffalo, New York; and all the members of the Wincrest Sportsman's Association, Buffalo, New York.

Melody Lawrence has been a source of strength for me throughout the fifteen years of this project's development. Her ready encouragement, her practical help in editing all the texts, and her visual insight are considerable factors in its realization.

For her many efforts in my regard, I dedicate this book to Melody with love and gratitude.

SILENT SCREENS

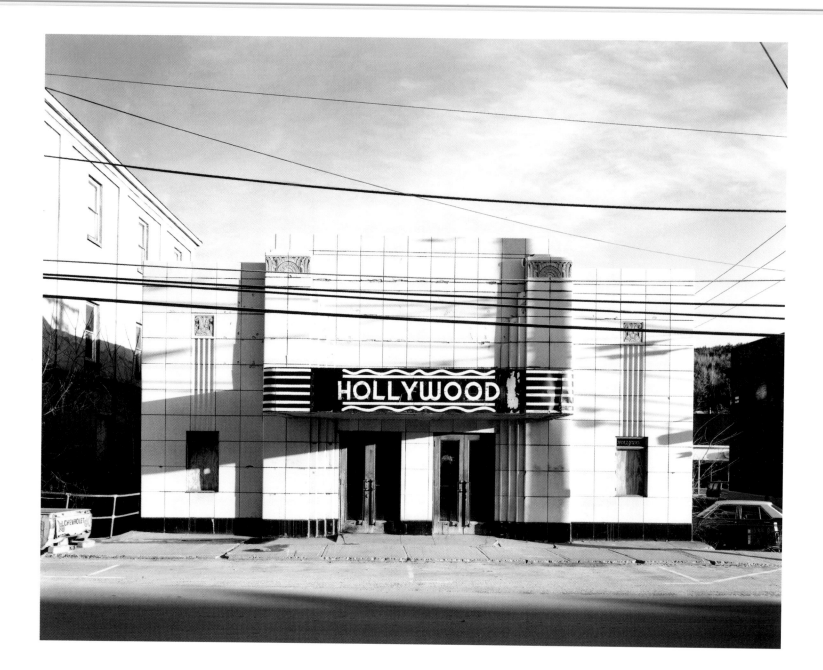

2

There's a tendency to rhapsodize about the lost world of small-town and urban neighborhood moviegoing, the prime years of which ran from the mid-1920s until midcentury. How can one imagine those old Roxys and Cameos without conjuring them as Last Picture Shows where Americans learned to yearn, as dime-store dream palaces where adventure and beauty reigned in larger-than-life display? Their warm romantic aura casts a regretful shadow over the efficient, boxy, multiplex theaters and the cool electronic glow of television and computer screens in our so much richer, yet diminished, media present. Nostalgia, however, carries us only so far toward understanding the place of these theaters in American movie culture. Sentimental memories may overlook a fundamental point: in the United States, popular entertainment is first of all a commercial culture, created and disseminated for private profit. We may come closer to the significance of such small theaters for movie culture by regarding them as branches of movie commerce—links, however modest, in a chain of motion-picture production, distribution, and exhibition that reached out from the United States to encircle the globe.

To speak of the significance of small-town and city neighborhood theaters in any larger scheme of movie commerce is surely counterintuitive. However important these local Bijous may have been to their communities and patrons, they were at best pocket change in the purview of the mighty motion-picture industry. Under standard distribution practice, a new film took from six months to a year to wend its way from picture palace to Podunk (the prints getting more and more frayed and scratched along the route). Even though the small-town theaters and their urban neighborhood counterparts made up the majority of the nation's movie houses, their significance, in terms of revenue returned to the major motion-picture companies that produced and distributed films, was paltry.

INTRODUCTION
Robert Sklar

In the standard, Hollywood-centered story of small-town and urban neighborhood movie theaters, these small theaters are, at best, extra players in a grand spectacle, a milling crowd far away from the headline stars, barely visible, out of focus. But there is another way of telling this tale, one that turns it on its head and acknowledges the viewpoint of the supernumeraries. From that unfamiliar angle, it could be argued that political concerns about community power and cultural control, rather than strictly economic value, gave these otherwise inconsequential theaters an inordinately important role in shaping the basic structure and practices of the American movie industry.

The familiar account of movie theater history follows the trail of federal agencies that spent the better part of three decades, from the 1920s through the 1940s, trying to make the case that a few big companies monopolized the movie trade in violation of antitrust laws. The type of monopoly they were accused of was known as "vertical integration" because it entailed control over all facets of an industry's operations; in the case of movies, these were production, distribution, and exhibition. A sticking point, however, was that although these major companies—Paramount, Fox (later Twentieth Century–Fox), Warner Bros., R.K.O., and Loew's (M-G-M)—clearly dominated production and distribution, they directly operated less than 20 percent of the country's movie theaters.

Finally, after a series of lower court cases produced numerous mitigating consent decrees, the U.S. Supreme Court in 1948 upheld the government's overall contention that the major companies operated an illegal monopoly. The Court argued that what mattered was not the quantity but the strategic importance of theaters owned. By controlling the metropolitan first-run theaters, the Court declared, the major companies were in a position to exercise monopoly power over the nation's entire exhibition system. There were little more than one hun-

dred of these theaters—less than 1 percent of the total—and the major companies operated more than 80 percent of them. The Supreme Court's ruling did not significantly affect the major movie companies' control over production and distribution; rather, to end the illegal monopoly, the Court focused on exhibition. Its ruling led to new consent decrees in which the companies agreed to divest themselves completely of their theater holdings.

How was it possible for ownership of approximately one hundred theaters to constitute the most salient detail proving the existence of a movie monopoly? Years of research by federal agencies and scholars of the film industry had made clear the means whereby the major companies determined what movies were to be played, when, and where, throughout the four-fifths of the theaters which they did not own or operate. Possession of the first-run theaters allowed these companies to shape the dominant discourse about movies. Advertising, publicity, and commercial tie-ins whetted the public's interest far beyond the theaters in which first-run movies were actually playing, and they sustained moviegoers' desire and demand as films flowed from center to periphery. More directly prescriptive were the rules and regulations that the major companies established through their distribution operations, which had been sources of friction and controversy between small theaters and the movie companies over many decades.

These included a system called "clearance," which ranked theaters in order of importance and established how soon after release a film would become available to a theater and how long it could run there. Other principal practices were block-booking and blind-booking. Through block-booking, distributors demanded that theaters rent films in groups or blocks, often ten films or more, rather than individually. Blind-booking meant that theaters were forced to make

their selections not only without seeing films in advance but sometimes with little or no information about the films.

Basically, a theater would be offered numbered units. Each unit would someday become a movie, but at the moment when the theater contracted for it, a script was likely not yet written nor were performers cast, a director assigned, or sound stages reserved. A movie company might know precisely in which theaters and on what days its films would be playing months in the future, when everything else about those films had not yet sparked a glimmer in its producers' and creators' eyes.

This system was deeply frustrating to small independent theater operators, whose trade associations were among the most vigorous supporters of the federal effort to break the major companies' monopoly. Traditionally, communities felt a need to have control over their cultural life, whatever its quantity or quality. This important principle underlies every discourse concerning movie theaters and the film industry, and it pertains even more broadly to questions of culture as a whole. To be sure, beyond strictly local events such as amateur theatricals or singing groups, even in the era before movies, towns and villages relied for their diversions on commercially produced programs created elsewhere and brought in by touring stage companies, vaudeville troupes, musical performers, lecturers, circuses, and the like. Conflicts no doubt arose between local tastes and preferences and the national or regional outlook of entertainment producers, but communities retained a certain power. They had to book the event, provide the hall, do the promotion, and, above all, constitute an audience. These responsibilities gave them leverage over the selection and presentation of cultural programs.

Outside the dense urban centers that supported the initial burst of motion-picture production, movie presentation followed the familiar pattern of earlier live cultural events. In fact, smaller communities frequently first experienced movies as part of live programs by touring lecturers, who added short, silent movies to their usual fare of photographic slides or magic lantern images. When feature-length films emerged in the years prior to the First World War, a common practice was for an entrepreneur to acquire rights to a movie for a specific territory and then hire existing halls from town to town to show it. (In the early days, when many small towns had not yet been wired for electric power, traveling exhibitors carried their own projectors and often their own generators to operate equipment and illuminate the hall.)

By 1910, as production expanded, along with more theaters dedicated solely to movies, there sprang up between producers and exhibitors a middle operation called "exchanges," which rented films to theaters. After the First World War, the movie business went through a chaotic struggle among its three component parts. It was at this point that mergers, takeovers, and bold expansions created the vertically integrated major companies which ran the Hollywood studios, operated the exchanges, and bought or built theaters to control the most favorable outlets for their movies and gain direct access to box-office revenue. Consolidation also occurred among theater owners who were not affiliated with the major companies; a substantial number combined into chains, or circuits, more effectively to bargain with the producer-distributors.

While the industry's powerhouses formed into larger and more concentrated units, movie culture in the towns and neighborhoods remained, of necessity, more local and dispersed. In the late 1930s, nearly 40 percent of all theaters were

in towns with a population of less than 2,500, and most of these towns had only one theater. The theater's average seating capacity was smaller than the national average and represented less than 20 percent of the total number of seats nationwide.

This disparity was exacerbated because the small-town theaters required more product than first-run big city houses did. It was typical for a small-town theater to offer three different programs weekly. The population base for such a theater could not support longer runs. Theaters with an average seating capacity of five hundred in towns with less than 2,500 population had a better chance of luring compulsive moviegoers three times a week than getting the whole town out for a weeklong run. On the other hand, a flagship first-run theater in a metropolis, with an average seating capacity of fifteen hundred, could prosper giving each picture a two-week run and sometimes even holding over popular movies an extra week.

Put another way, theaters in small towns required more than one hundred fifty movies a year, whereas a big city picture palace needed only twenty-five or so. This gap became apparent to the major companies quite early in their development. As a film industry analyst remarked in the 1940s, "rentals for the same picture may range from $10 to $10,000." Although these are probably extreme or rare examples—and the average low figure was generally a little more, while the high end was somewhat less—let us take them for a moment as a basis for comparison. Movie companies renting one hundred fifty movies at $10 per two- or three-day run would earn $1,500 annually from a small town or neighborhood theater. Renting twenty-five movies at $10,000 a week would bring in a quarter million dollars per year from a first-run house. Given the overhead involved in shipping three feature prints each week, one may surmise that servicing the

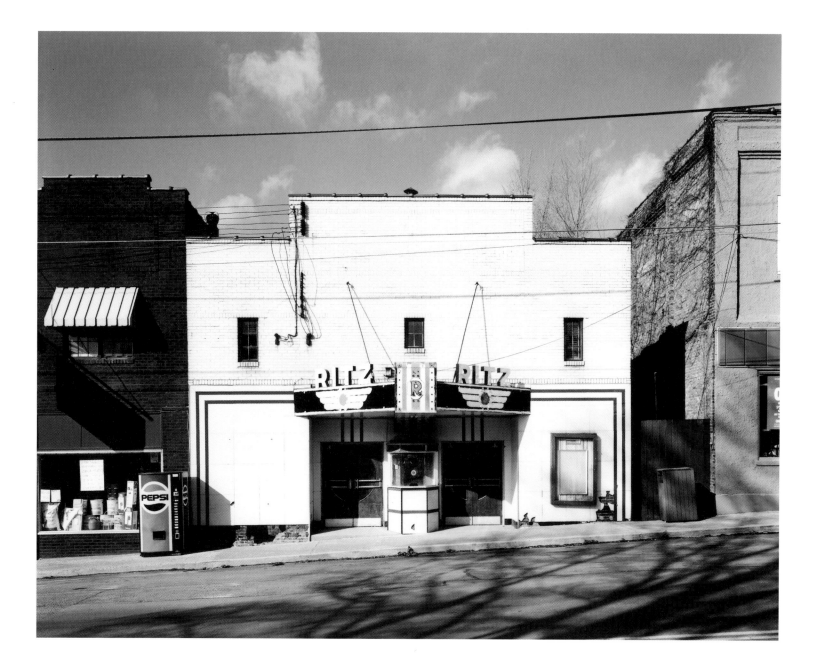

RITZ, ANSTED, WEST VIRGINIA, 1989

small theaters across the nation could hardly have been better than a break-even proposition for the major movie companies.

Why did the movie companies countenance this unpropitious situation? Nearly every aspect of it seems to go against sound economic logic. Not only were the small theaters, at best, of marginal financial value to the producer-distributors, their very existence demanded a higher volume of production than might otherwise have been the case. In the heyday of the small-town and urban neighborhood theaters, film industry gadflies contended that the quality of American movies was adversely affected by the fact that an unnecessarily large number were made. In the 1930s, the eight major Hollywood companies released from 318 to 408 features annually. Imagine how many fewer (and, so the argument goes, better) films might have been made if the industry had produced films primarily for the picture palaces and had not had to ship one hundred fifty movies a year to the typical small theater. Perhaps the film industry would in any case have adopted the reigning industrial doctrine of "Fordism"—assembly-line methods and economies of scale—regardless of the small theaters' needs, but, in the event, it was the small theaters' requirements that considerably shaped the way movies were made and sold.

It was not economic logic that mattered under the circumstances; it was political logic. The small theaters, organized into trade associations, developed a political voice. The principle of local control over culture resonated in state legislatures and in the nation's capital. In the 1930s, some hinterland theaters vocally protested the representations of metropolitan crime and sexual behavior that movies imported into their communities; their discontent underlay congressional attempts (ultimately unsuccessful) to impose federal censorship over movies, an addition to the existing state and municipal movie-censorship bod-

ies. And it was on the basis of theater owners' complaints that congressional committees considered bills to outlaw block-booking and blind-booking. The Justice Department's antitrust charges against the motion-picture companies, which culminated in the Supreme Court's 1948 ruling, were grounded in part on a philosophical commitment of the Franklin D. Roosevelt administration to the value of community control over culture.

If the small-town and neighborhood theaters considered that they had won a victory with the consent decrees signed in the aftermath of the Supreme Court decision, they were not allowed much time to celebrate. By 1948, motion-picture attendance, which had reached an all-time peak in 1946, had already noticeably declined—and television, with its overwhelming inroads into the moviegoing habit, had barely begun. Less than two decades later, movie theaters had lost 60 percent of their average weekly attendance and more than half of the twenty thousand theaters operating in the 1940s had closed. Broadcast television, in its dominant years from the 1950s to the 1980s, eroded local control over culture even further than the movies had.

Eventually, the movie industry learned to use television to its own advantage. In the 1970s, using the small screen as a national advertising medium, the movie companies promoted and publicized their films across the entire country simultaneously. The old distribution system had become obsolete. Now, building on the impact of television exposure, the object was to circulate movies as widely as possible. After long decline, the construction of movie theaters boomed— typically, multiscreen operations in suburban shopping malls. Prints of each week's new films were shipped to hundreds and even thousands of theaters, each of which had become a first-run venue. The movie companies prospered as never before—and in the 1980s, the 1948 consent decrees were vacated, permit-

ting the major companies once again to own theaters. The particular requirements of their intimate antagonists—the small-town and urban neighborhood theaters—no longer existed. The archaeological image of the closed theater recalls a lost world in which, behind the marquee, central dilemmas and conflicts of twentieth-century American culture played offscreen.

THE PLATES

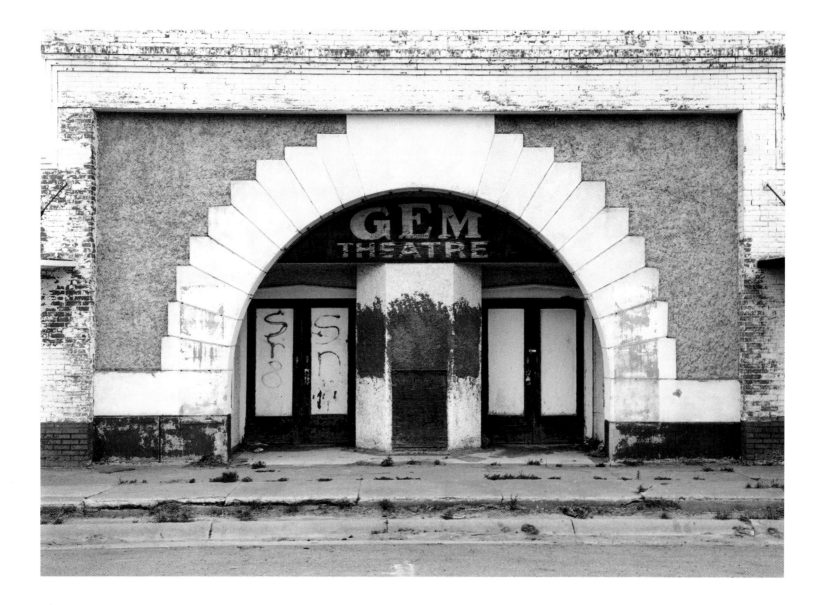

GEM, CLAUDE, TEXAS, 1985

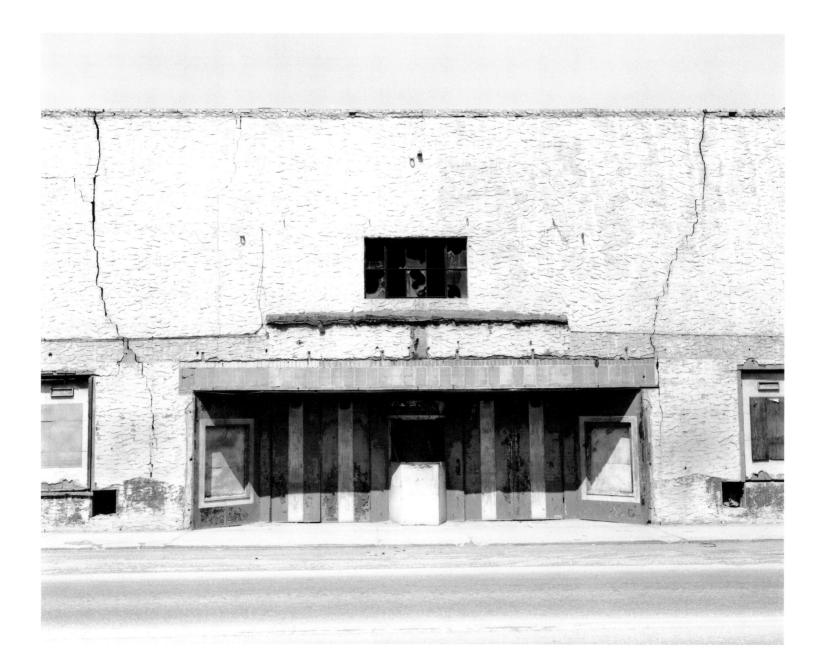

ALPINE, RAINELLE, WEST VIRGINIA, 1989

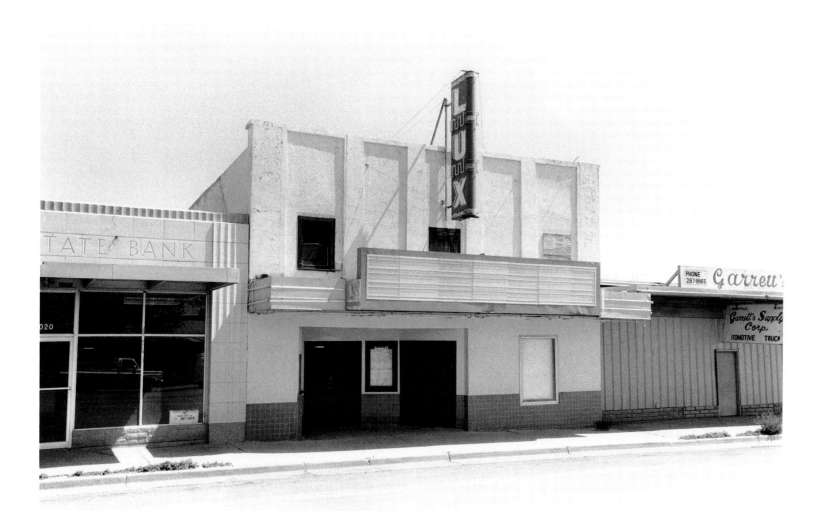

LUX, GRANTS, NEW MEXICO, 1984

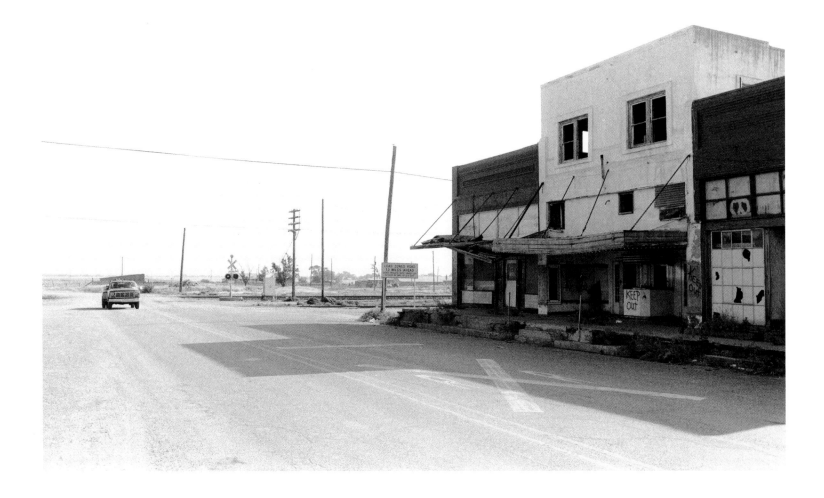

18

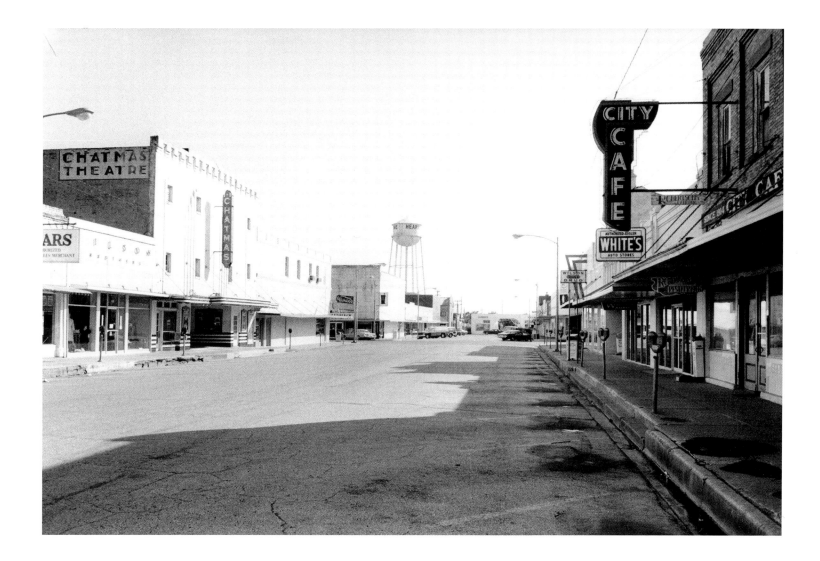

CHATMAS, HEARNE, TEXAS, 1980 19

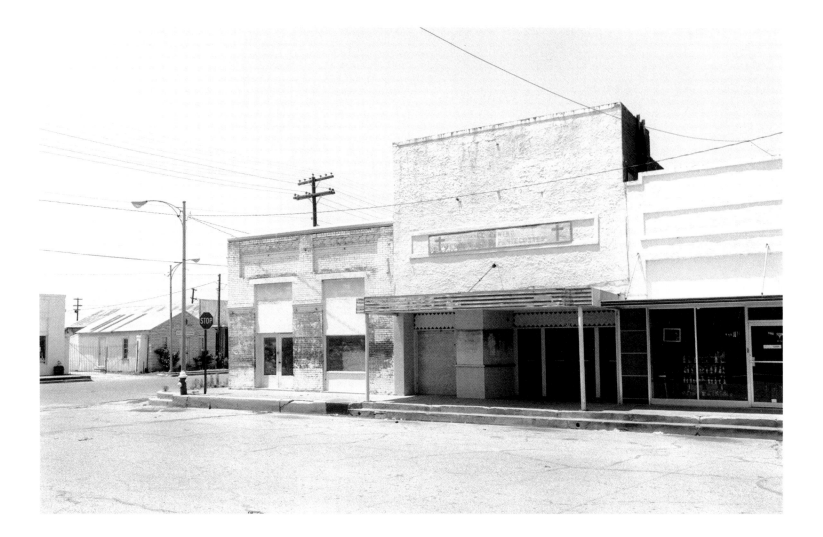

20

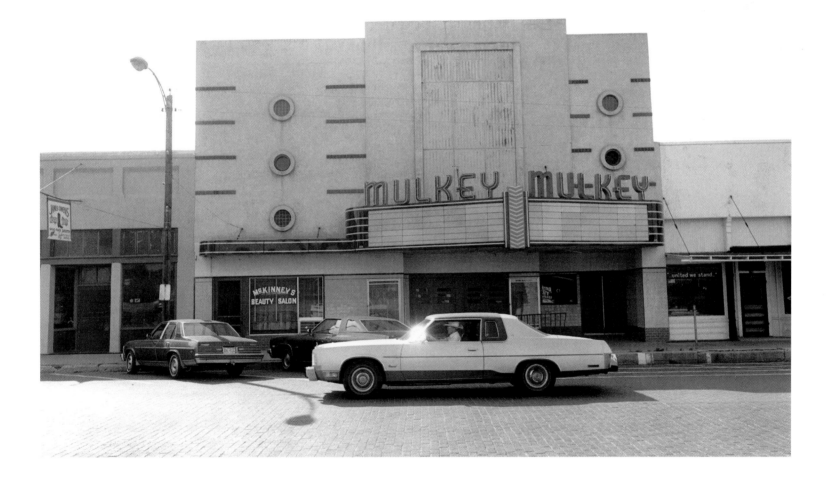

MULKEY, CLARENDON, TEXAS, 1985

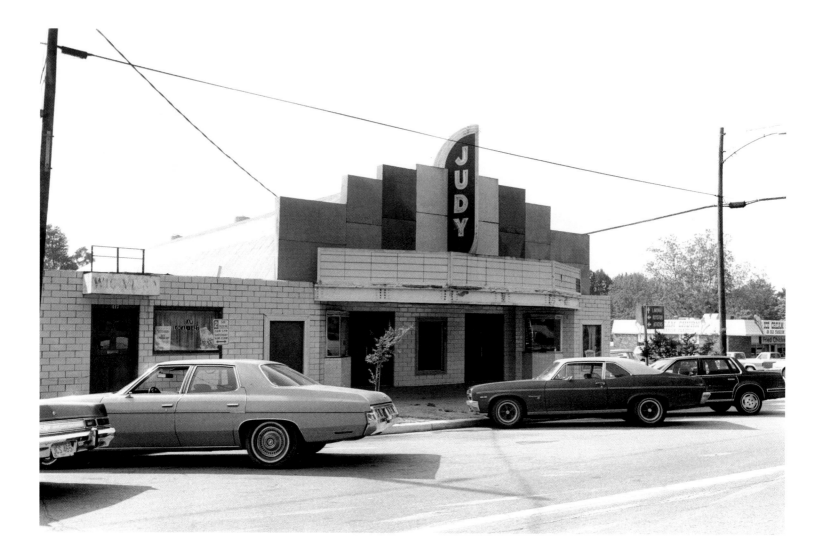

JUDY, HARTWELL, GEORGIA, 1985

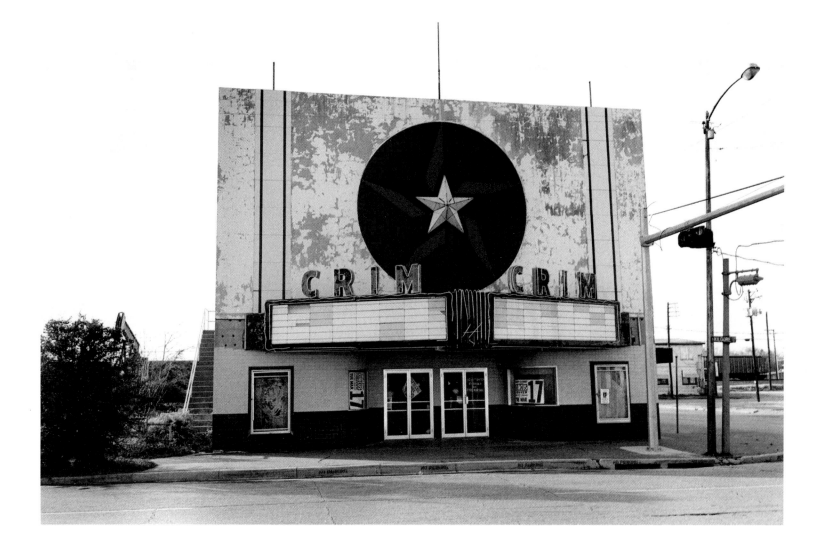

CRIM, KILGORE, TEXAS, 1980

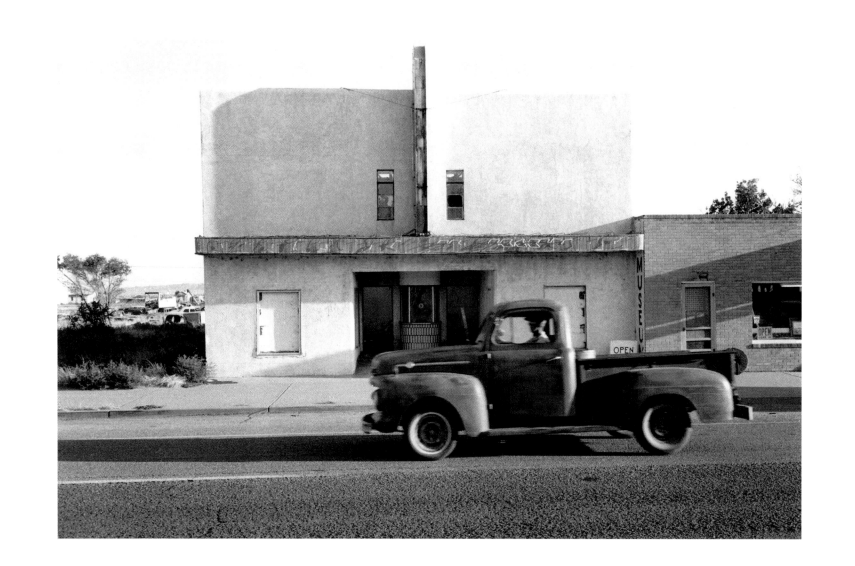

24

The sociological moment that *The Last Picture Show* was meant to dramatize had come, in the last two decades, to hundreds

of villages. The youth had moved out, or television had moved in, or both, and now from one coast to the other and from the

Gulf to the Dakotas the picture shows stood dead. There were so many of them, and the starkness of their blank marquees and

posterless fronts was so eloquent of other styles of living, other times, that one could hope that some present-day Walker Evans

would photograph a few hundred of them before they all cave in, or are sold and turned into restaurants, antique shops,

garages, and boutiques.

 Such elegiac feelings as were aroused in me by the sight of all those dead picture shows were provoked, I believe, not so

much by the fact that times have changed and a great mode of popular entertainment has partially broken down or because

I recognize that small-town kids today are deprived of a simple source of fantasy or a simple means of escapism, as by the

melancholy aspects of the empty buildings themselves. In fact, picture shows are hard to convert into restaurants, garages,

or boutiques, and in small towns, where development capital is not plentiful, they often stand vacant for years before anyone

shows up with enough money to turn them into something else. Thousands are probably standing empty and unconverted in

America right now, and, after one has driven past even a few score of them, they make an unforgettable collective impression

—structural Quixotes, exhausted and brought to rest by brute reality, yet retaining in the gaunt and stubborn angles of their

facades a suggestion of the visions, cheap but romantic, that once rolled like great clouds across their screens.

LARRY McMURTRY, from *Film Flam*

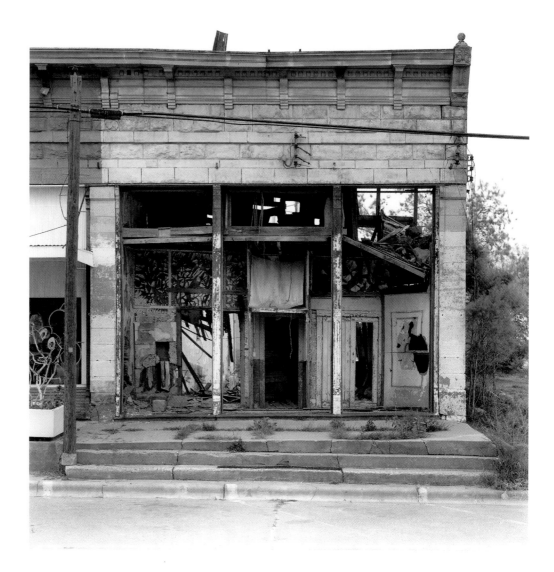

ROYAL, ARCHER CITY, TEXAS, 1988

The picture show, they called it in the South. Before radio or television, there were movies. Even after radio's advent, the sights of the cinema were not to be challenged, and for more than a decade after television's ascent the picture palaces outlived the steady demise of the smaller houses; but finally they all went.

The closing of New York City's mammoth Roxy was a shock to me as a young man. The old Paramount near Times Square closed, and also the Capitol, and the Mayfair—which became the DeMille and then was shuttered. Even the 6,500-seat Radio City Music Hall stopped showing movies in the mid-seventies. These places were a vivid part of my childhood and my teenage years—and I lived in Manhattan. Imagine all the kids who had only one or two choices and those were taken away.

Though I grew up in New York City, I still had plenty of experiences of these more typical movie houses in places where the little theaters seemed like converted community centers, places that smelled of pine and popcorn—at summer camp in Oxford, Maine, for example. I looked forward to the occasional weekend movies as a thirsty person yearns for water. There was comfort even in the relative discomfort of those little theaters, a sense of security. Many of my earliest filmgoing experiences were at the Museum of Modern Art, where my father took me to see silent films that he had grown up with. These memories of childhood movie-watching in small theaters in Maine or in bigger theaters in Manhattan are not dissimilar. They all have to do with looking at a screen in the dark.

The Last Picture Show (1971) offers a look back at the experience of going to the movies when we were young. When the theater in a town was closed, it could no longer form part of the experience of growing up; people were robbed

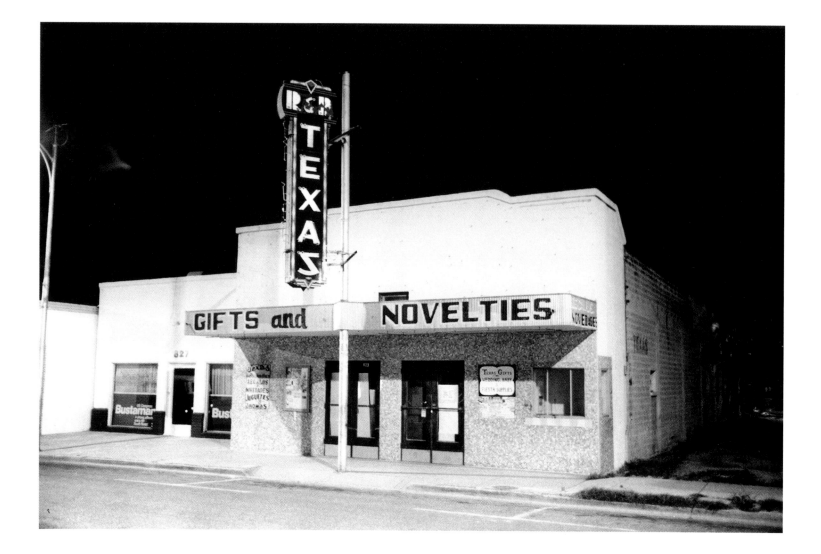

TEXAS, DEL RIO, TEXAS, 1984

of this kind of communal memory that is also so very individual. When I was preparing the film of Larry McMurtry's novel, and then a few years afterward another period film, *Paper Moon* (1973), we researched picture houses around the locations we had chosen. For both films we had scenes that featured a movie theater. On *Paper Moon,* we had to build a facade of a movie house, and we searched for a good name for our "theater." There was a real movie house in Russell, Kansas, that I especially liked, so we duplicated it, naming our theater "Dream." The name seemed to embody what the movie experience was for so many back then: a dreamlike escape from the often quietly desperate lives a great many people lived.

We chose Archer City for *The Last Picture Show* after traveling all over Texas looking for the perfect town. It turned out that Archer City had all the elements we needed. This is hardly surprising since Archer City is Larry McMurtry's hometown, the town he wrote about in the book. The facade of the Royal Theater was reconstructed by our designers and crew to match what had once been there. The ticket booth and the general entranceway were still there, but we had to fix them up so that they looked functional. The actual theater, the interior, was a burned-out shell. It looked somewhat better, but not much, than what you can see in the sequel, *Texasville* (1990). For the sequences inside the movie theater, we took the company to another town called Olney, which still had a functioning little movie house.

A theater is a visible connection to the outside world. The Royal, placed on the main street, shows its importance in being one of the first things you come to when you enter the town and one of the last things you see when you leave. It is a vision that connects you with a wider world; a world of larger-than-life adventures and dreams—a visible pop mythology for the twentieth century.

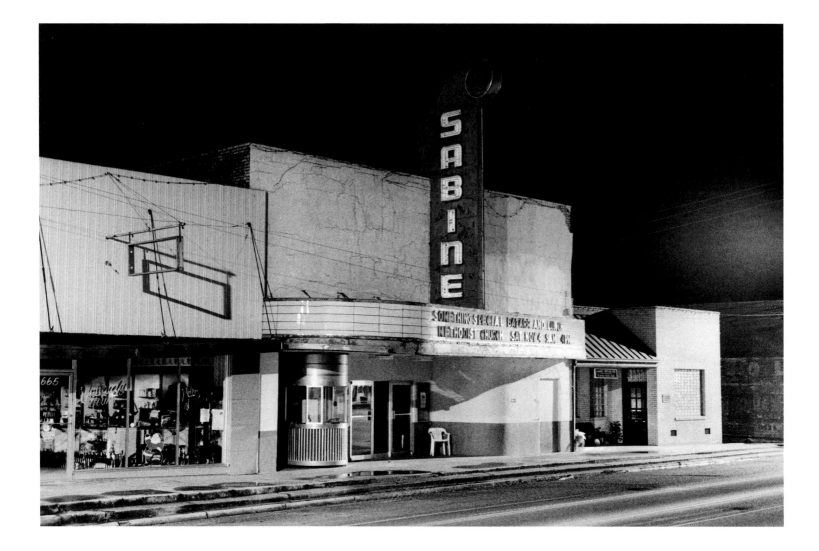

SABINE, MANY, LOUISIANA, 1995

The shuttering of a town's only movie theater is rather obviously a metaphor for the shuttering of the town itself, a certain closing off or insularization. A definitive ending to a particular way of life.

Movies, like any popular medium, must—even in some fun-house mirror fashion—reflect the society they come from, and so do the theaters in which we see them. The small-town movie theater seems now to recall a more deeply innocent time, when a quarter often bought you two features, a newsreel, a comedy short, a travelogue, a cartoon, a serial, and coming attractions. You could walk in any time, too. Hardly anyone in America went to the beginning of movies until Alfred Hitchcock's campaign for *Psycho* (1960), when late arrival was forbidden. These were not pretentious times, and these venues (a very recent, impersonal word to describe where an event happens) were often simple, too.

Unfortunately, we are living in a time without much innocence or magic. We are in a period which Orson Welles predicted when he said that the Roman Circus ended its life and that of the Roman Empire with real sex and real killing. We now have a more sanitized in-home version, but the brutalization of the public is inescapable. The newer theaters with larger screens and up-to-date sound equipment promise a technical perfection that is just waiting for talent to animate its myriad possibilities. But an emphasis on technique has gotten us to the current sorry state in which we are largely dealing with fantasy rather than attempting to deal with reality. Our fascination with technology leads us ever toward astonishing effects and away from the investigation of the complexities of life and death.

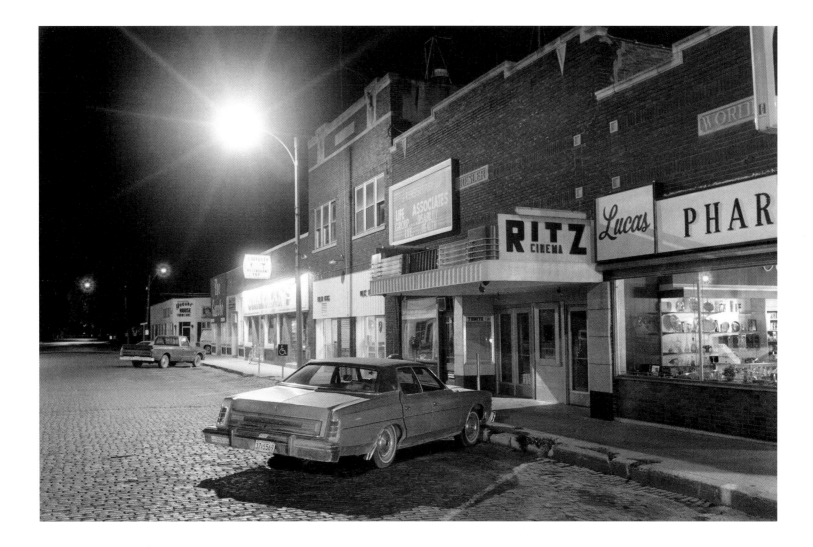

RITZ, RENSSELAER, INDIANA, 1985

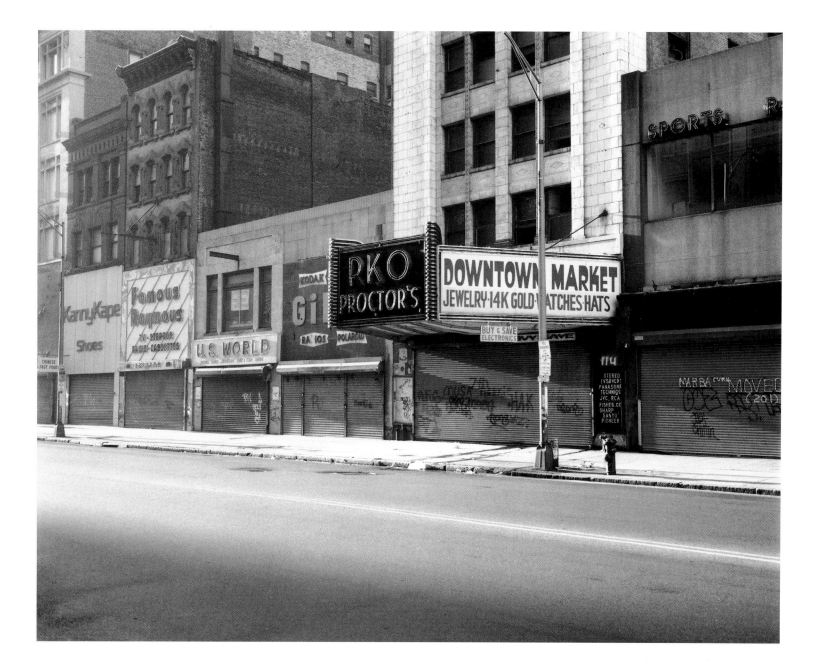

RKO PROCTOR'S PALACE, NEWARK, NEW JERSEY, 1987 33

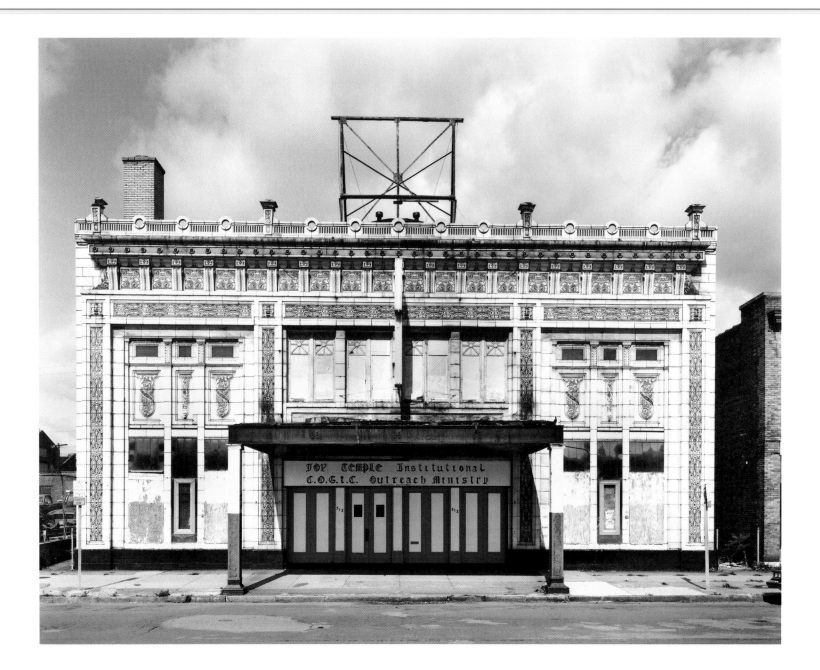

34

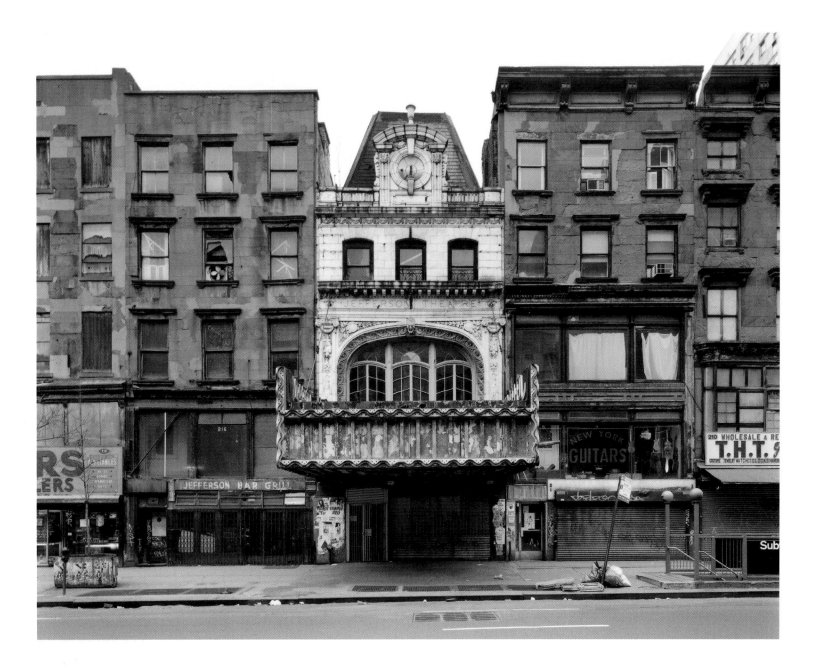

JEFFERSON, NEW YORK CITY, NEW YORK, 1986 35

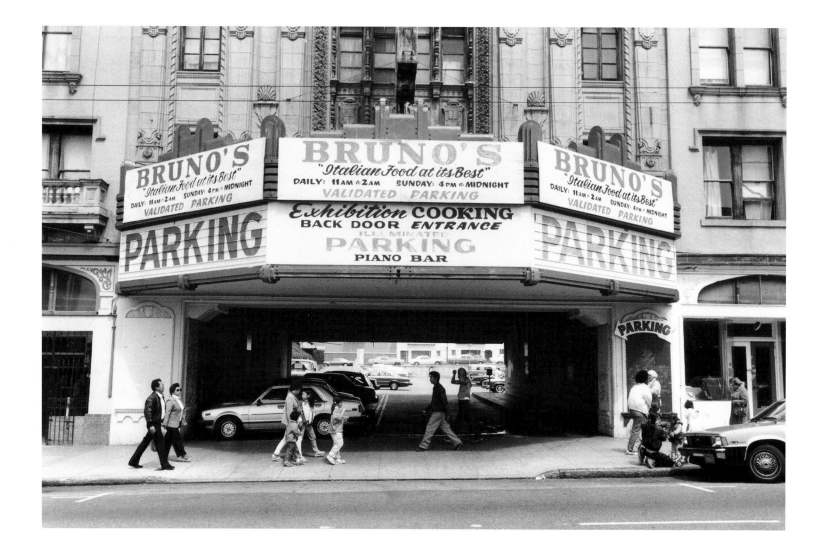

EL CAPITAN, SAN FRANCISCO, CALIFORNIA, 1985

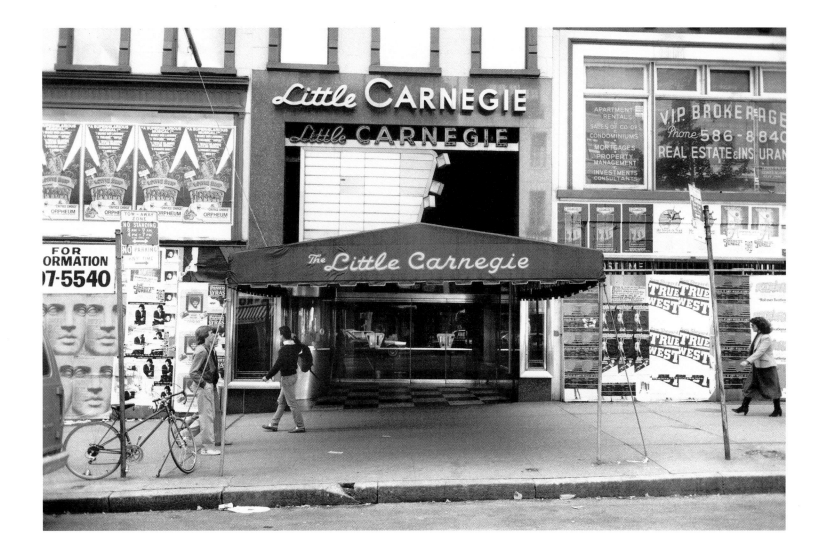

LITTLE CARNEGIE, NEW YORK CITY, NEW YORK, 1983

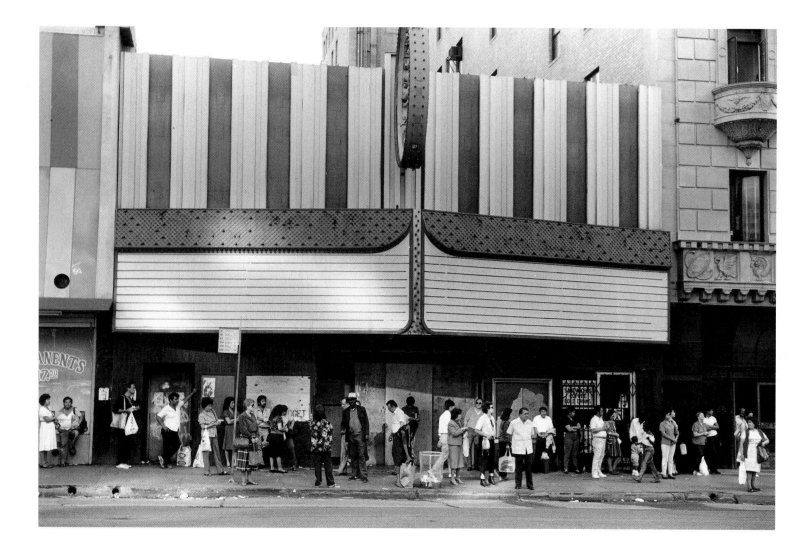

TOWN, LOS ANGELES, CALIFORNIA, 1986

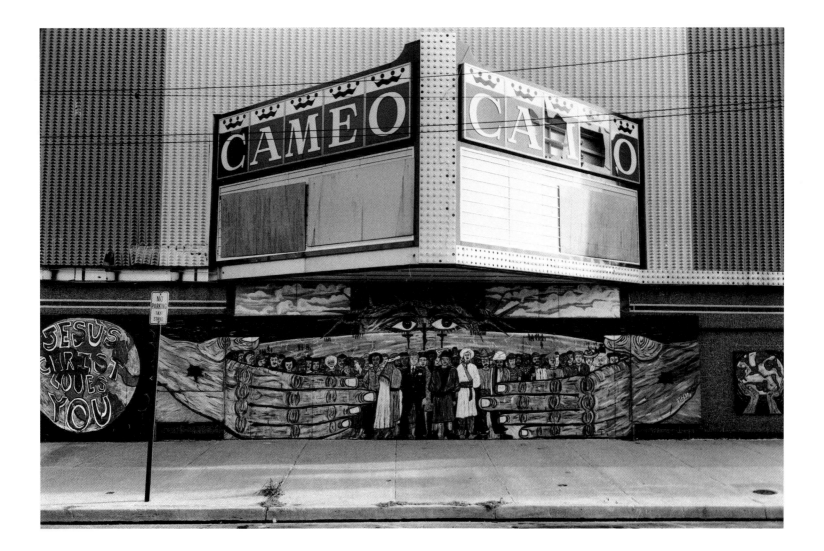

CAMEO, KANSAS CITY, KANSAS, 1982

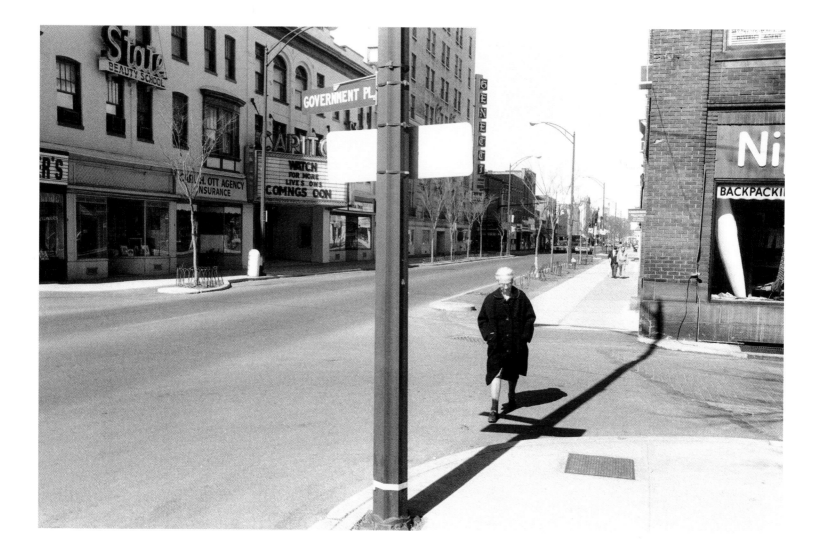

40

Most of us did not see movies in their first run at the palaces of the metropoli-
tan centers. We waited until they came to the small-town and inner-city neigh-
borhood second-run theaters, along with companion features that seldom had
a first run. For us, going to the movies was a casual habit. It did not make any
difference what the outside, or even the inside, of the movie house looked like.
We completely forgot, or simply didn't realize, that the idols on the screen were
actually on celluloid in cans. Movies were loops in time, ventures out of our
own lives, that took us with them and returned us unharmed.

The theaters were plebeian hideaways-from-reality; my own theaters, the
Glenwood in Flatbush and the Howard in Howard Beach, were family theaters,
whose only exclusivity could have been the price of admission. These theaters
exemplified the essential egalitarianism of the movie-going experience.

That world is gone, a casualty of the ambitions and the mobility enshrined in
the movies themselves. This is the nature of America. These now-empty streets
speak to the population shifts that the territorial vastness of the country has
made possible.

A REMEMBRANCE

Andrew Sarris

STRAND, WESTFIELD, MASSACHUSSETTS, 1984

ABERDEEN, NC *Aberdeen*

AKRON, OH *Allen,*
Boulevard, Cameo,
Colonial, Ellet, Ideal,
Orpheum, Southern,
Thornton, Tivoli

ALAMO, TX *Alamo*

ALBANY, GA *Liberty*

ALBERTVILLE, AL *Carol*

ALBUQUERQUE, NM *Chief,*
Coronado, Ernie Pyle,
Rio, State

ALEQUIPPA, PA *Strand*

ALTOONA, AL *Altoona*

AMERICUS, GA *Martin*

ANAHUAC, TX *Rig*

ANDERSON, SC *Criterion*

ARDMORE, OK *Jewel*

ASBERRY PARK, NJ
St. James

ASHBURN, GA *Ideal*

ASHEVILLE, NC *Imperial,*
Plaza, State

ASHLAND, KY *Alfon,*
Capitol, Columbia,
Edisonia, Lyric

ATHENS, TN *Athens*

ATLANTA, GA *Centre,*
Eighty-One, Empire,
Lincoln, Ponce de Leon,
Strand

ATLANTIC CITY, NJ *Astor,*
Beach, Capitol, Cinema,
Colonial, Embassy,
Hollywood, Lyric, Surf

AUGUSTA, KY *Odeon*

BALTIMORE, MD *Gwynn,*
Metropolitan, New Albert,
New Lincoln, Region,
Royal

BARTLESVILLE, OK *Arrow,*
Lyric, Osage, Rex

BATAVIA, NY *Family*

BATESBURG, SC *Carolina*

BATON ROUGE, LA
Louisiana, McKinley,
Ogden, Paramount

BEAUMONT, TX *Liberty,*
Peoples, Rio, Star, Tivoli

BENAVIDES, TX *Empress,*
Rita

BESSEMER, AL *Frolic,*
Grand

BILOXI, MS *Avenue, Bay*
View, Buck, Harlem,
Meyer, Roxy, Star, Toy

BIRMINGHAM, AL *Avon,*
Capitol, Champion,
Eighth Avenue, Frolic,
Melba, North
Birmingham, Strand,
Woodlawn

BLACKWELL, OK *Bays*

BLOOMFIELD, KY *Bloom*

BOLING, TX *Roxy*

BOONVILLE, MO *Casino,*
Lyric

BORDENLONVILLE, LA *Joy*

BOWIE, AZ *Bowie*

BRAWLEY, CA *Eureka*

BRILLIANT, AL *Boston*

BRODHEAD, KY *Gray*

BROWNSVILLE, KY *Lindsey*

BUFFALO, NY *Century,*
Columbia, Keith,
Lafayette, Little
Hippodrome, Old Vienna,
Orpheum, Rivoli, Shea's
Kensington, Shea's
Roosevelt, Victoria

BURLINGTON, NC *Carolina,*
State

CARNEGIE, PA *Dixie, Grand*

CARROLLTON, KY *Richland*

CASA GRANDE, AZ *Chief*

CATLETTSBURG, KY *Gate*
City, Halls

CEDARTOWN, GA *Cedar*

CHARLESTON, SC *Dixie*

CHARLESTON, WV
Ferguson, Greenbriar,
Kearse, Lyric, Rialto

CHARLOTTE, NC *Broadway,*
Imperial, Savoy, State,
Tryon

CHATTANOOGA, TN *Amusu,*
Cameo, Capitol, Grand,
Harlem, Liberty, Rialto,
State

CINCINNATI, OH *Americus,*
B. F. Keith, Cox, Dixie,
Elmwood, Idle Hour,
Monte Vista, Norwood,
Ohio, Orpheum, Pekin,
Plaza, Rialto, RKO Albee,
RKO Capitol, RKO
Family, RKO Grand,
RKO Lyric, RKO Palace,
RKO Paramount,
RKO Schubert, Sunset,
Western Plaza

CIRCLEVILLE, OH *Grand*

CLINTON, KY *Strand*

CLYDE, OH *Clyde*

COLUMBUS, GA *Georgia*

COMMERCE, GA *Ritz, Roxy*

CONCORD, NC *Cabarrus,*
Paramount, Pastime,
Roxy

COOLIDGE, AZ *San Carlos,*
Studio

COWPENS, SC *Gem*

CORAOPOLIS, PA *Fifth*
Avenue

CORNELL, NY *Majestic,*
Strand

CORNING, NY *Fox*

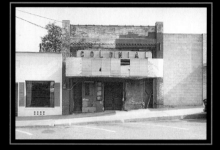

DEMOLITIONS
NOTED

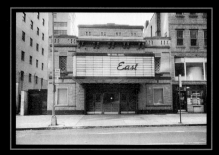

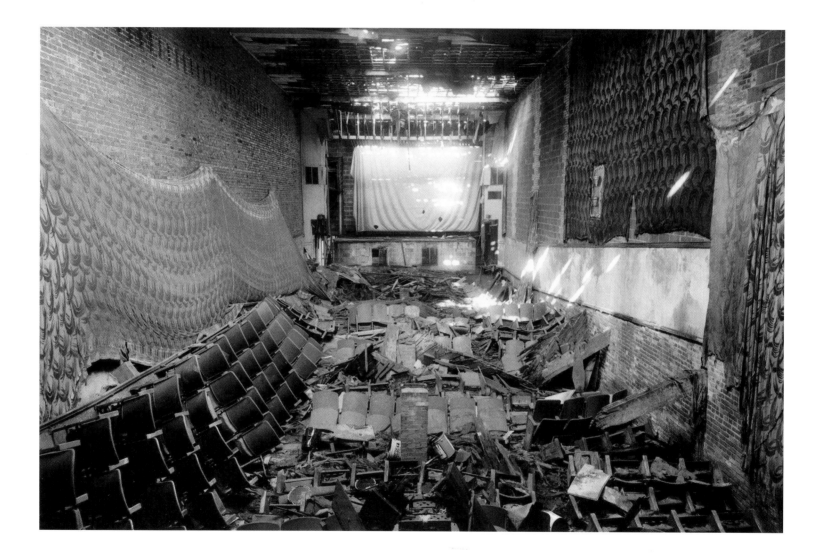

44

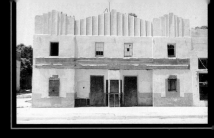

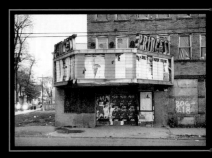

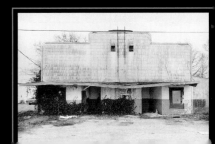

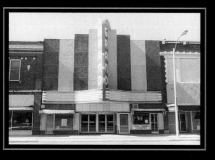

LANCASTER, OH *Broad,*
Palace
LA PLACE, LA *La Place*
LA PORTE, IN *Fox, LaPorte*
LAWRENCEBURG, KY *Lyric*
LITTLE CHUTE, WI *Little*
Chute
LOGANSPORT, IN *Logan,*
Roxy
LORAIN, OH *Elvira, Ohio,*
Palace, Pearl, Tivoli
LOS ANGELES, CA *Aliso,*
Boulevard, Carleton,
Florence, Gaity,
Hippodrome, Jade, Lido,
Linda, Loma, Manchester,
Maynard, Muse, Nidean,
Optic, Ravenna, Rosalyn,
Savoy, Terrace, Uptown
LOXLEY, AL *Victory*
MACON, GA *Capitol, Rialto*
MADISON, WI *Parkway,*
State
MADISONVILLE, KY *Capitol*
MAGDALENA, NM *Alameda*
MANITOWOC, WI *Empire*

Strand
MARION, WI *Marion*
MASONTOWN, PA *Liberty,*
Rex
MATHIS, TX *Texas*
MAYFIELD, KY *Princess*
MCALESTER, OK *Chief,*
Star, V
MEBANE, NC *Mebane*
MEDINA, NY *Park*
MEMPHIS, TN *Ace, Anway*
MERCEDES, TX *Rio*
MILBURN, WV *Milburn*
MOBILE, AL *Berkley,*
Empire, Harlem, Loop,
Pike, Roosevelt
MONTGOMERY, AL *Charles,*
Rogers, Strand
MORENCI, AZ *Royal*
MORGANTOWN, KY
Hollywood
MOSS POINT, MS *Joy*
MT. STERLING, KY *Tabb,*
Trimble
MT. VERNON, KY *Vernon*
NEWARK, NJ *Branford,*

Ashton, Bell, Center,
Delta, Dixie, Escorial,
Fine Arts, Globe,
Granada, Happy Land,
Joy's Strand, Lincoln,
Napoleon, Nola, Palace,
Town, Tudor
NEWPORT NEWS, VA *Dixie,*
Paramount
NIAGARA FALLS, NY
Cataract, La Salle,
Rainbow, Strand
NICHOLASVILLE, KY
Nicholas
NORCO, LA *Royal*
NORFOLK, VA *Carver,*
Dunbar, Gem, Lenox,
Manhattan, Menrose,
Plaza, Regal, Roxy,
Visulite
NORWALK, OH *Moose*
OAK HARBOR, OH *Portage,*
Royal
O'FALLON, IL *State*
OILTON, TX *Oilton*
OKLAHOMA CITY, OK

Royal, Strand
OSAWATOMIE, KS *Kansas,*
Osawa
OSWEGO, NY *Capitol,*
Strand
OTTAWA, IL *Orpheum*
OWENSBORO, KY *Bleich,*
New Malco, Strand
OWENTON, KY *Pastime*
OZARK, MO *Ozark*
PADUCAH, KY *Rialto*
PALACIOS, TX *Capitol,*
Granada, Hollywood
PANAMA, OK *New*
PASCAGOULA, MS *Pix*
PAVO, GA *Pavo*
PELAHATCHIE, MS *Park*
PENSACOLA, FL *Belmont,*
Gulf, Ritz, Roxy
PERRY, OK *Perry, Roxy*
PERTH AMBOY, NJ *Ditmus*
PERU, IN *Ritz, Roxy,*
Wallace
PHILADELPHIA, PA *Alden,*
Alhambra, Avon, Bell,
Belmont, Booker, Breeze

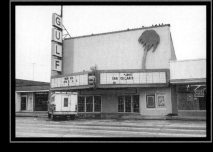

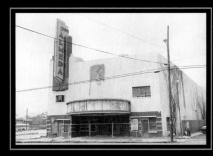

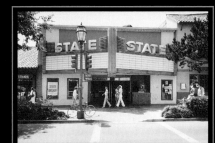

THE PEKIN THEATER

Pekin, Illinois

OPENED: November 27, 1928
CLOSED: In the early 1970s

Efforts were made to convert the Pekin into a dinner theater, a medical office building, and a civic center.

All such efforts were unsuccessful. Demolition of the Pekin Theater was completed on March 11, 1987.

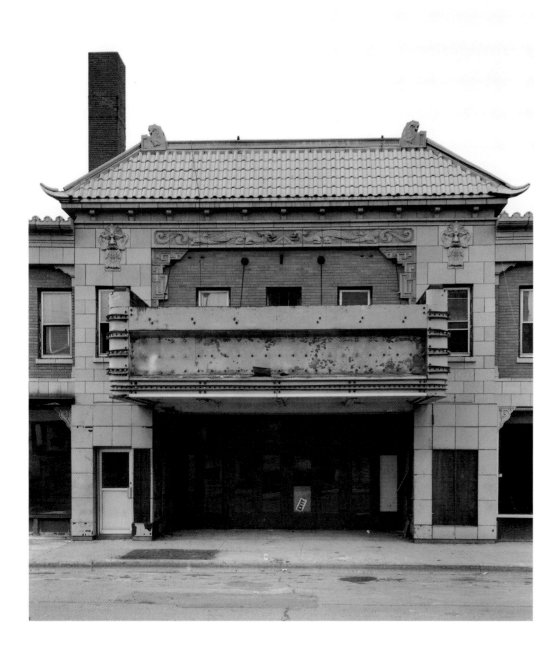

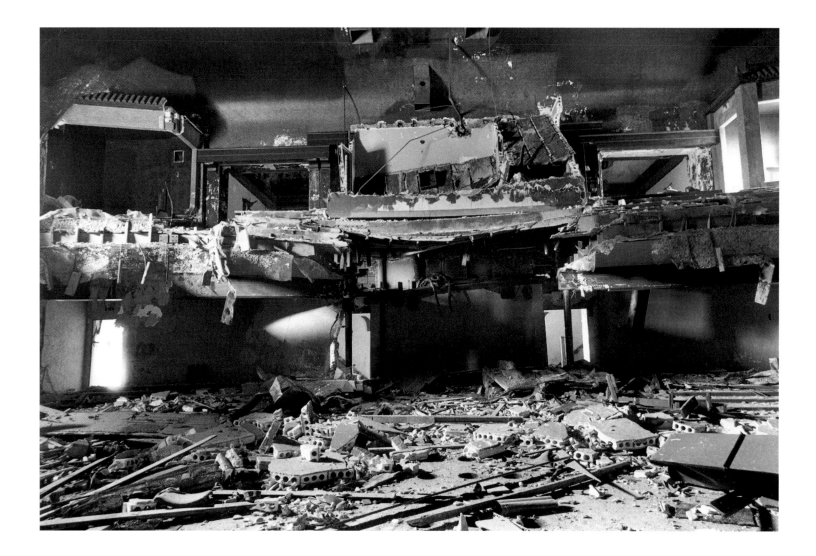

50

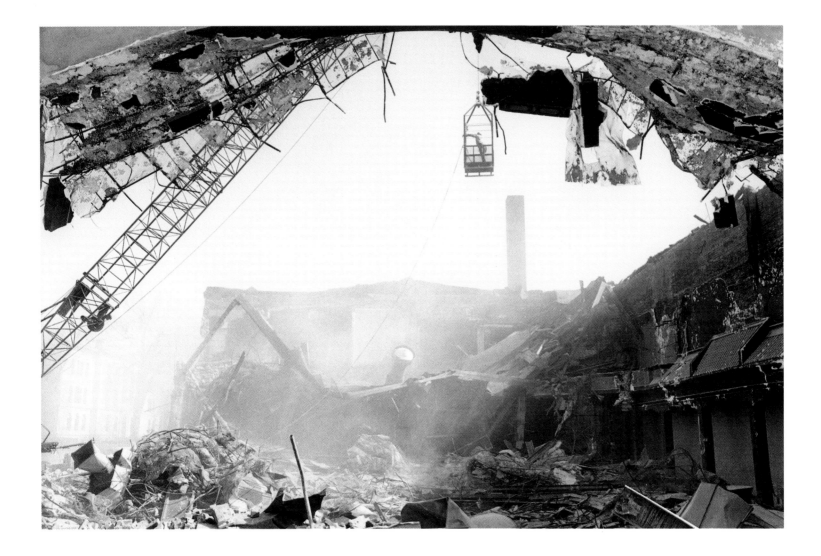

PEKIN, PEKIN, ILLINOIS, 1987

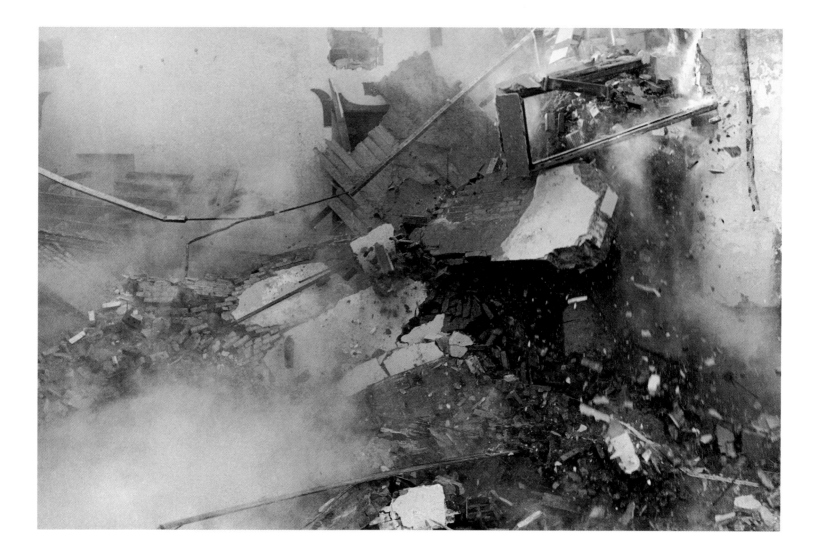

PEKIN, PEKIN, ILLINOIS, 1987

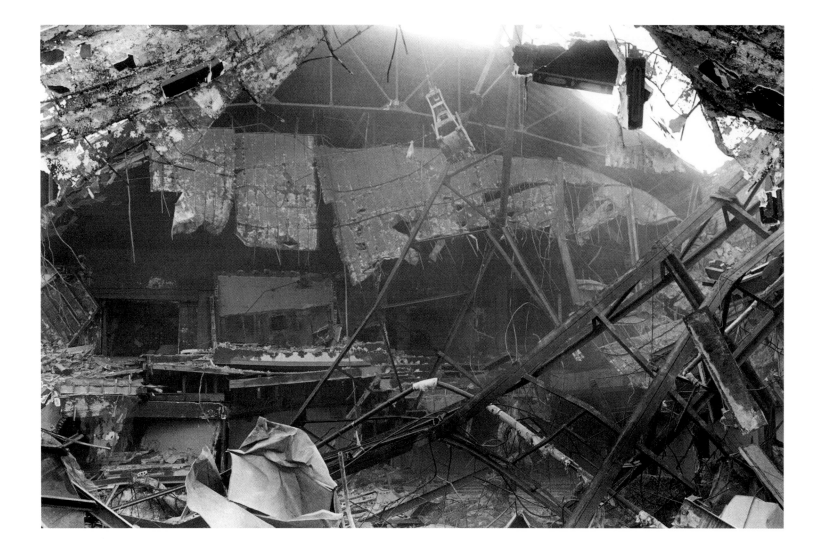

PEKIN, PEKIN, ILLINOIS, 1987 53

"They called me up and said they had found something, a wallet at the Pekin Theater,"

Robert D. King, age 56, of 7 Florentine Court, said. "I said, 'Yeah, it's mine. I lost it in 1959 or 1960.'"

from a report in the *Pekin Daily Times* (December 30, 1986) on the salvage operations at the Pekin Theater,

where coins, wallets, and a class ring were found in concrete ducts running beneath the main floor.

PEKIN, PEKIN, ILLINOIS, 1986

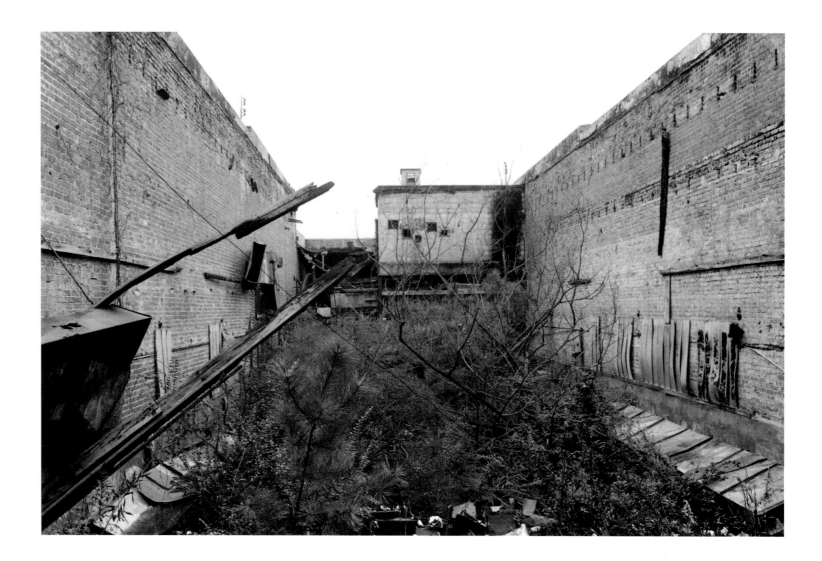

MAGEE, MAGEE, MISSISSIPPI, 1985

If one was an adolescent living in Richmond, Virginia, in the fifties, moviegoing was largely a peer activity. Already teenagers were becoming a separate group, a subculture with its own cars, music, and idols of discontent.

Movies hadn't begun to challenge the Establishment in overt ways, but they contained the seeds of destruction of the small-town community and what it stood for. For though they might exalt the working man or woman over the aristocrat, and disdain social divisions in America's supposedly classless society, the narrative drive and character motivation of the stories was ever onward and upward. The most engaging heroes were possessed by wanderlust; the smartest working-woman heroines believed in self-betterment; the increasingly dominant tone was against provincialism.

The closing down of small movie theaters across the country signaled the passing of a way of being together. Something happened when families no longer gathered for the big meal in the middle of the day as a consequence of fathers working too far from home. The evening meal was never as leisurely, as expansive: the children were already headed out the door. In looking at these photographs, you can almost hear the noise of the cars racing out of town, to another section, to another city. The silence of abandonment is deafening. You must be of a certain age to hear it and thus know that what you are seeing is the ghost of the community that hangs over these empty places.

We have left our pasts behind. We, the descendants of people who were themselves fugitive, restless, challenging fate; we, in the search for fulfillment, or renewal, or individuality, have left these markers in our wake.

A W A K E

Molly Haskell

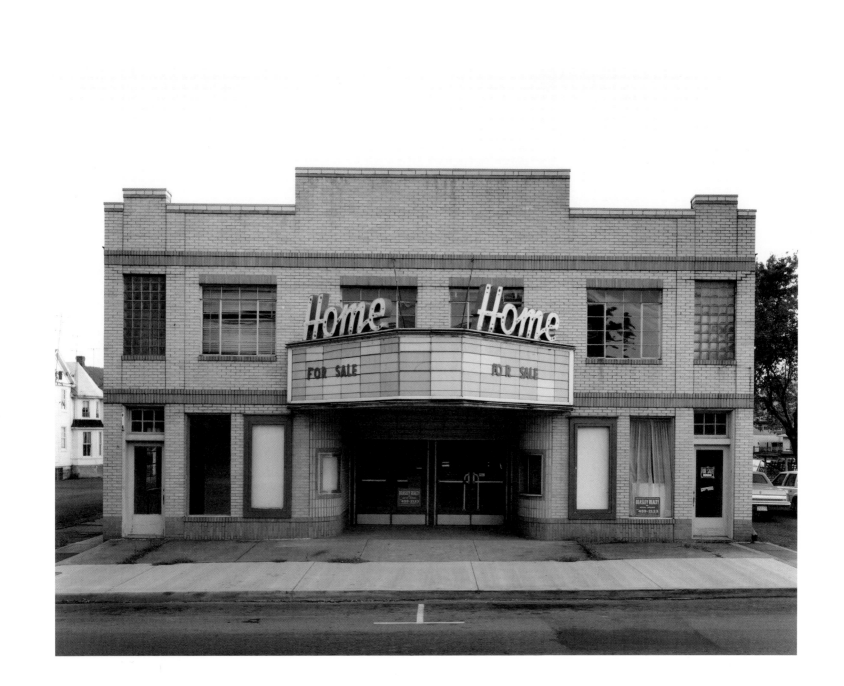

HOME, STRASBURG, VIRGINIA, 1989

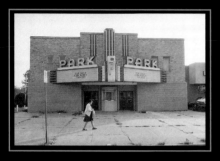

CONVERSIONS NOTED

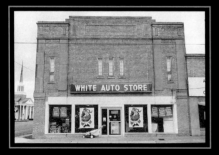

ADA, OK *Ritz* • Perkins Sewing Center / beauty parlor

AKRON, OH *Dayton* • Dayton Apartments, *Gem* • Berneath Drugs, *Paramount* • Bread of Life FMM Church / Sunrise Bait Shop, *Rialto* • Litho Arts Printing, *Royal* • Testa Electric Co.

ALBUQUERQUE, NM *El Rey* • El Rey Liquors, *Kino* • Community Arts Center, *Sandia* • Aamco Transmissions

ALICE, TX *Rex* • Iglesia Cristiana de Amor y Poder

ALMA, WI *Alma* • Masonic Lodge

ALPINE, TX *Granada* • Big Bend Youth for Christ

ALVIN, TX *Tex* • The Tractor Store

AMBRIDGE, PA *State* • Ambridge Medical

ANTHONY, TX *Anthony* • Porter Lumber Yard

ARCADE, NY *Arcade* • Fabric Forum

ARDMORE, OK *Globe* • Tipp's Downtown Furniture Centre, *Park* • Main St. Lounge, *Ritz* • ice cream parlor / mall,

Star • Bluebonnet Feed

ARLINGTON, KY *Arly* • Hocker Appliance Store

ASBURY PARK, NJ *Savoy* • Sweets and Greets (greeting cards & candies)

AUGUSTA, WI *Augusta* • People's State Bank

AVONDALE, AZ *Avon* • TriCity Tang Soo Do (karate)

BALTIMORE, MD *Boulevard* • $10 and Under Store, *Horn* • Holy Temple & Holiness Church of Deliverance, *Monroe* • Pratt Furniture

BARLOW, KY *Lyndel* • Well's TV Sales & Repairs

BATH, NY *Bath* • Bath National Bank

BAXTER SPRINGS, KS *New Baxter* • Baxter Floral

BAY CITY, TX *State* • professional offices, *Texas* • Rhema Fellowship Church

BAYFIELD, WI *Princess* • gift/framing shop

BAYTOWN, TX *Bay* • Bay Tabernacle

BEAUMONT, TX *Liberty* • First City Bank of Beaumont

BEAVER, PA *Beaver* • Allan's Jewelers

BEDFORD, PA *Bedford* • Ickes Drug Store, *Blue Ridge* • Ethan Allen Johnson & Son Furniture

BELLEVUE, OH *State* • pinball/gifts

BLACKWELL, OK *Palace* • American Legion, *Rivoli* • Equity Apartments

BLYTHE, CA *Rio* • The Potters House Christian Center

BOWLING GREEN, KY *Diamond* • Fountain Square Church

BRACHETVILLE, TX *Palace* • Western Auto / barbershop

BRANSON, MO *Owen* • Branson City Limits Music Theatre

BRIDGEVILLE, PA *Delphus* • Di Mario's Restaurant, *Strand* • Bridgeville Fitness Center

BRILLION, WI *Brillion* • Furniture Plus Inc.

BROOKSHIRE, TX *Wayside* • engine shop

BROWNSVILLE, TX *Grande* • Rivcon Tepas (clothes), *Iris* • Frontier Lounge, *Mexico* • La Nueva Moda & Jewelry Corner, *Queen* • Emphasis (clothes)

BUFFALO, NY *Apollo* • Bible Days Revival Church, *Avon* • furniture store, *Broadway* • Joy Temple Institution C.O.G.I.C. Outreach Ministry, Broadway Lyceum • *Open Door #1* Church of God in Christ, *Capitol* • Downtown Post #64 American Legion, *Circle* • Arab AM Federation of Western New York, *Colonial* • Baptist Church, *Kensington* • Open Door #4 Church of Christ, *Lincoln* • Walter Construction, *Lovejoy* • Lovejoy Community Swimming Pool, *Marlowe* • Iglesia Misionera Asamblea Cristiana, *New Ariel* • Clowes Building, *Rivoli* • office building, *Senate* • Wavecrest Sportsman's Association, *Shea's Seneca* • office building, *Strand* • Autumnwood Manor Banquet Facility

CALEDONIA, NY *State* • Sam's Saloon

CAMBRIDGE, NY *Cambridge* • A&M Printers

CANEYVILLE, KY *Mary Jane* • Sawmill Hardware

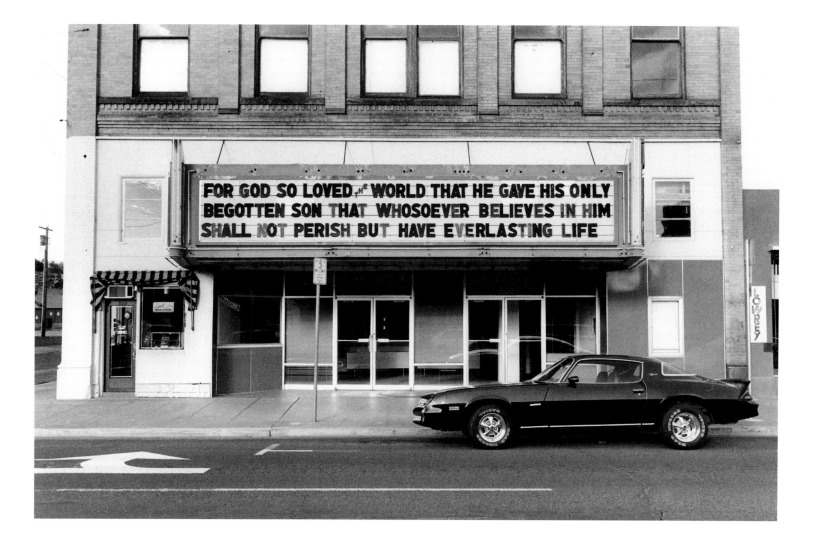

UNITED ARTISTS, PENDLETON, OREGON, 1985

61

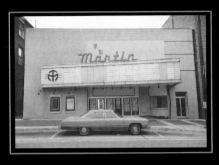

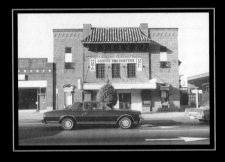

CANONSBURG, PA
Alahambra • H&R Block
CARNEGIE, PA *Liberty* •
Duda's Pharmacy, New
Carnegie • Office of
Employment Security
CARROLLTON, KY *Royal* •
McCormick
Monogramming
CARTHAGE, NY *Strand* •
Branaugh Memorial Club
CASHTON, WI *Welcome* •
Cashton Welding
CASSVILLE, WI *Cass* •
Dresens Welding
CENTRALIA, IL *State* •
Village Greenery
CHANDLER, AZ *Rowena* •
Chandler Primary Day
Care Center
CHETEK, WI *Grand* • Coast
to Coast Hardware
CHILDRESS, TX *Monogram* •
Sports Unlimited
CHILLICOTHE, IL *Palace* •
Master Craft Cleaners
CINCINNATI, OH *Andalus* •
St. Bernard Family
Worship Center, Avon •
The Church of the Lord
Jesus Christ of the
Apostolic Faith, Glenway
• Pete Shea's Pharmacy,
Guild • Sound Electronics,
Hyde Park • Pier I
Imports, Roselawn •
Aquadath Achim

(synagogue), *Uptown* •
Uptown Church, *Vogue* •
Thriftway Food and
Drug, *West Hills* • North
American Van Lines
CIRCLEVILLE, OH *Circle* •
Keith's Clothing
CLIFTON, AZ *Martin* • Job
Training Center
CLOVIS, NM *Lyceum* •
Performing Arts Center,
Mesa • recording studio
COLBY, WI *Colby* • Colby
Apartment Building
COLEMAN, WI *Coleman* •
Frievalt's Upholstery
COLUMBUS, KS *State* •
David Newberry Floor
Covering
COLUMBUS, TX *Oaks* •
Jamboree
COMFORT, TX *Comfort* •
performing arts center
CONFLUENCE, PA *Liberty* •
Betty's Gift Shoppe
CORAOPOLIS, PA
Coraopolis • Josephs Fine
Footwear
CORINTH, KY *Corinth* •
Kolhoff Machine Shop
CORNING, NY *Plaza* •
Century 21 (real estate)
CORPUS CHRISTI, TX
Grande • Braslau
Furniture, *Harlem* • stor-
age/offices, *Melba* • thrift
store

CUBA, NY *Cuba* • real
estate / insurance office
CUERO, TX *Rialto* • Coca-
Cola Co., *Trot* • Dixie
Furniture & Appliance
Co.
DALLAS, TX *Beckley* • St.
Stephen Missionary
Baptist Church, *Beverly
Hills* • Oakcliff Christian
Center, *Kessler* • U.S.A.
Embroidery and
Monogram, *Logow* • Gods
Greater Holy Temple,
Majestic • performing arts
center
DANVILLE, KY *Kentucky* •
Hub Frankel Department
Store, *State* • Kindaid
Furniture, *Towne* •
Minuteman Press
DAVIS, OK *Kerr* • Marilyn's
Realty
DEL RIO, TX *Princess* • fab-
ric store, *Rita* • perform-
ing arts theater, *Texas* •
novelty store
DELTA, OH *Lyric* • Nancy's
Floral Designs / Kern's
Refrigeration
DEMING, NM *Rancho* •
Rosie's Beauty Shop
DETROIT, MI *Ace* •
International Gospel
Center, *Admiral* • Brown's
Chapel Missionary
Baptist Church, *Alhambra*

• Kenwood Market, *Alvin*
• Grand Auto Parts,
Arcadia • Schoolboys
Shoe Shine Parlor / apart-
ment building, *Beverly* •
Jehovah's Assembly,
Chandler • Classic Auto
Salon, *Crystal* • Cheers
Party Store, *Franklin* •
Video & Love Boutique
(lingerie, novelties),
Imperial • Radoe Heating
and Cooling, Inc., *King* •
Detroit Temple, *Midtown*
• Evangelistic Tabernacle,
Oliver • Joshua Supreme
Council Grand Masonic
Congress, *Oriole* • New
Bethel Baptist Church,
Perrien • Mountain of
Faith Missionary Baptist
Church, *Priscilla* • House
of God Church, *Rialto* •
The Body of Christ Taber-
nacle Church, *Rosedale* •
Greater Mt. Zion Taber-
nacle, *Senate* • Detroit
Theatre Organ Club,
Stanley • Friendly Mis-
sionary Baptist Church
DONNA, TX *Plaza* • Lee
Optical
EDINBURG, TX *Alameda* •
videos, *Aztec* • Bob's
Sewing Machine Center,
Juarez • Omega Electonics

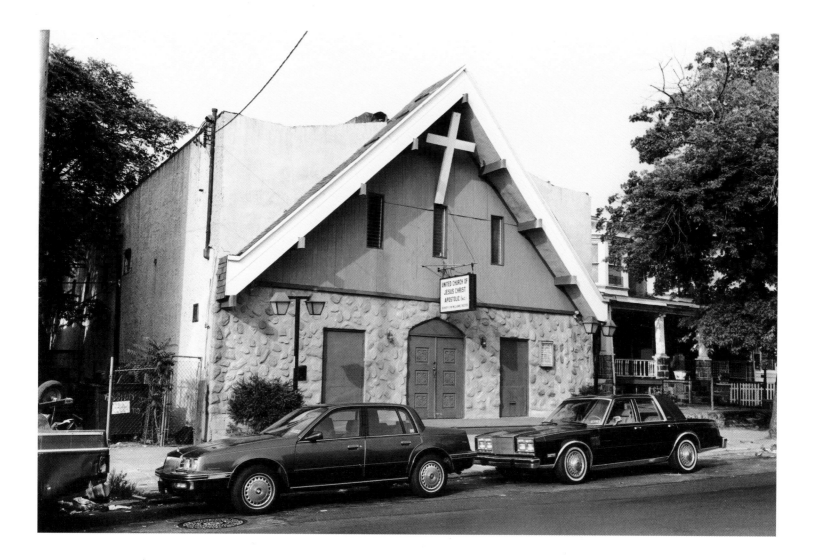

SPRUCE, PHILADELPHIA, PENNSYLVANIA, 1988

ELIZABETH CITY, NJ *Elizabeth • Spencer Auto Parts, New • Lynn's Fashions / G&S Fitness Center, Regent • Marburn Curtain Warehouse, Royal • B.L.B. Meat Market*
ELLSWORTH, WI *Ellsworth • Village Community Center*
ELLWOOD CITY, PA *Majestic • Helen's Dress Shop*
EL PASO, TX *Azteca • Café Olé Restaurant / Cosmopolitan (topless), Colón • church, Mission • United Steel Workers of America, State • Texas Finance*
EMINENCE, KY *Eminence • Purvis Tavern*
ERLANGER, KY *Gayety • Dusing Brothers Ice*
EUREKA SPRINGS, AR *New Basin • antiques*
FAIRCHILD, WI *Fairchild • Judy's Curl*
FALFURRIAS, TX *Alameda • Alameda Electronics*
FARMERSVILLE, TX *Carnes •*

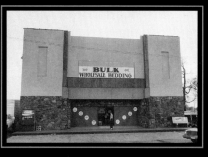

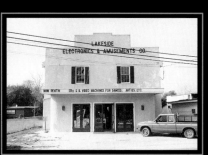

FENNIMORE, WI *Fenway • Silent Women Night Club*
FORT SUMNER, NM *Granada • auto supplies*
FORT WORTH, TX *Bowie • Camp Bowie National Bank, Como • Perry's Used Furniture, Parkway • Winn-Dixie*
FREDERIC, WI *Frederic • Coast-to-Coast*
FREEDOM, PA *Freedom • Freedom Hotel*
FREEPORT, TX *Freeport • furniture store, Ora • nightclub*
FROSTBURG, MD *Palace • Allegheny County Visitor Information Center*
GAINESVILLE, TX *Plaza • The Shady Spot Studios (framed objects), Ritz • lawyer's office*
GALENA PARK, TX *Galena • Templo Galilco*
GALESVILLE, WI *Gale • Galesville Public Library*
GARY, IN *Roxy • Andros Appliances/Furniture*
GAYS MILLS, WI *Kickapoo •*

Schools
GEORGE WEST, TX *Rialto • Gonzales & Co. Plumbing Supplies, West • Elliot & Waldron Abstract Co.*
GILA BEND, AZ *Rio • warehouse*
GLASGOW, KY *Trigg • Bernard's Clothing Store*
GOLIAD, TX *Goliad • Sammies Hair Design*
GRAFTON, WI *Grafton • Village Hall/Library*
GREENVILLE, TX *Texas • Showtime Lingerie*
HAGERSTOWN, MD *Colonial • Faith Chapel, a New Testament Church*
HARRISON, AR *Plaza • Old Town Mall*
HARRISVILLE, NY *Royal • Jim Scanlon's Bakery*
HATCH, NM *Mission • Loya's Lounge*
HEAVENER, OK *Liberty • Liberty Pawn*
HEBBRONVILLE, TX *Casino • dance hall*
HICKMAN, KY *Ritz • Showboat, Inc.*

Territory Wholesale Supply, Inc.
HONDE, TX *Park • Park Place (professional offices)*
HORNELL, NY *Hornell • Brooks Drug Store*
HORSEHEADS, NY *Horseheads • R&M Auto Parts*
HOUSTON, TX *Alabama • bookstore, Blue Bonnet • bank, Deluxe • furniture storage, Globe • DH Tires Heights • art gallery, Holaran • Golden Star Food Market, Iris • office building, Lyons • church, Navaway • Iglesia de "Fe y Poder," State • Living Word Outreach–Jesus Is Lord, Stude • Stude Revival Center, Uptown • office building*
INDEPENDENCE, KS *West Main • K&L Krafts*
JACKSON, KY *Jaxson • Dollar Store, Pastime • Western Auto*
JERSEY CITY, NJ *Bergen •*

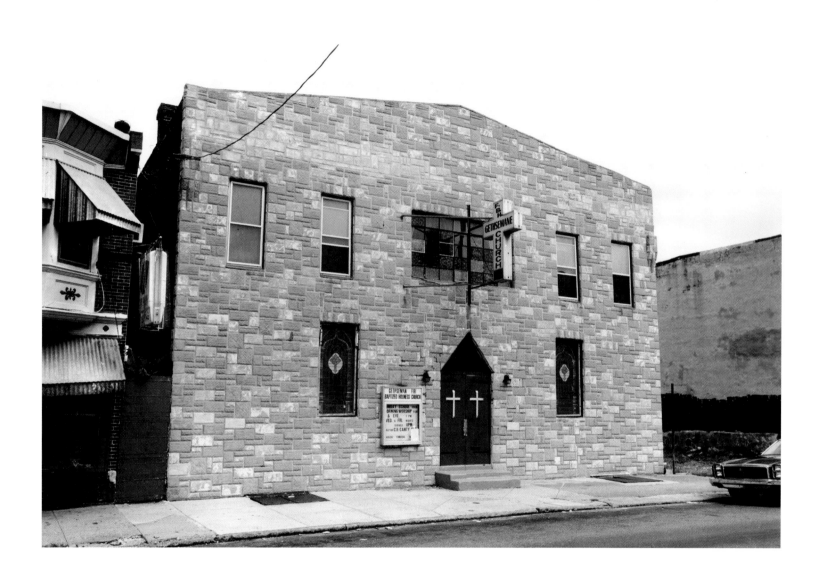

YORK, PHILADELPHIA, PENNSYLVANIA, 1988

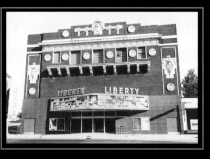
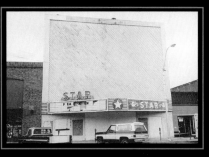

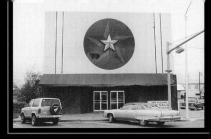

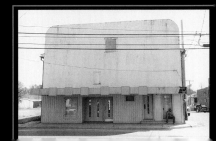

Fair Super Market, Grand • York Lovelier Fashions for Less, Grant • Faith Tabernacle "Move of God Inc.," Green Hill • Eglise de Dieu, Hamilton • Pennsylvania Deliverance Evangelistic Center, Harrowgate • Kensington Roller Rink, Imperial • Marvin Fives Food Equipment Corp., Jerry • Pennsport Caterers, Jumbo • Fox Electric, Lane • Brandow Dodge, Lawndale • Time for Tots (childcare center), Leader • Belmont Discounts, Lehigh • Fellowship Revival Center of Love, Liberty • Golden Eagle Caterers, Lindley • Second Cousins Caterers, Logan • Deliverance Evangelistic Church, Mayfair • Thrift Drug, New Broadway • Missionary Church of Christ, New Lyric • Victory Community Baptist Church, New Mayfair • High Rollers Nite Club, New Palace • Theatre for the Living Arts, Orient • Kingsessing Electric Shop, Pennypack

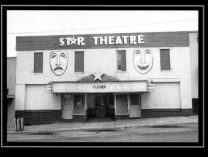

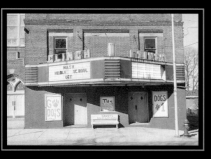

• Barney Daley's Fine Furniture and Bedding, President • President Caterers, Regal • Cameo Caterers, Renel • Upper Room Baptist Church, Rex • 2nd Timothy Tabernacle Baptist Church, Rialto • New Bethel African Methodist Episcopal Church, Richmond • Fishers Hardware, Ridge Avenue • Boldware Temple Revival Center, Ritz • Demarests Soft Pretzel Bakery, Ritz • Ritz Hall, Riviera • Loring Aluminum Products, Southern • Venus Banquet Rooms, Spruce • United Church of Christ, Star • Star Mall, Strand • Apostolic Assembly, Towne • Muhammad International Auto Sales Center, Tyson • Mirrow's Furs, Venice • Venice Plaza Caterers, Vogue • Faith Tabernacle, Wayne • New Found Joy and Deliverance, Church of God in Christ, Wynne • Wynne Plaza, York • Gethsemane First Baptized Holiness Church
PHOENICIA, NY Phoenicia •

auction house
PITTSBURGH, PA Heights • Open Door Guidance Center, J. P. Harris • City Club, Loew's Ritz • Hanover Shoes for Men / Allison's Place, Metropolitan • A Plus Mini Market, Northside • North Side Deposit Bank, Paramount • Stephany Auto Salvage, Penn • Junction Heating and Cooling, Perry • Board of Education Annex, Perry Highway • Tiny's Pet Place, State • Landmark Savings Association, Warner • Warner Center (mall)
PLAINFIELD, WI Plainfield • Gospel Lighthouse Church
PORT ARANSAS, TX Port • bait & tackle
PORT CLINTON, OH Clinton • Ohler and Holyhauer Plumbing Supplies
PORT HENRY, NY Essex • Jimmy's Newsroom
PORT ISABEL, TX Roxy • Texas Cleaners
POTEAN, OK Kemp • Bridgemans Furniture, Ritz • Eddie McCroskie, Attorney at Law

RAYMONDVILLE, TX Ramon • drugstore, Rey • Light House of Praise Church
RICHMOND, TX Lamar • Ft. Bend Counseling
ROBSTOWN, TX Gulf • Rolandas Coffee Shop
ROCHESTER, NY Astor • Richard Steven's Carpet Broker, Cameo • Cup and Saucer Restaurant, Embassy • Ejercito de Salvacion, World • Holy City Church of God in Christ
ROCHESTER, PA Family • furniture storage
ROCKAWAY BEACH, NY Park • Nina's Pizza / Rockaway Beverage
ROCKWOOD, PA Nickelodeon • Rockwood Insurance Co.
ROGERS, AZ Victory • flea market / bookstore
ROSENBERG, TX Cole • Country Music
SABINAL, TX Rio • Sabinal Senior Citizens Center
SALISBURY, PA Village • Showalters Furniture
SAN ANTONIO, TX Broadway • Trinity Bank, Olmos • S. A. College of Medical and Dental Assistants, Inc., South

San • Lamars Garage, Uptown • St. Ann's Parish Center, Woodlawn • Iglesia Cristia

AN BENITO, TX Reeves • Elvapor Bakery

AN DIEGO, CA Adams • Victory Christian Church, Metro • Buck Motors, North Park • North Park Christian Fellowship, Victory • Refuge Church of God of the Apostolic Faith

ANDOVAL, IL Sando • H&H Welding

AN MARCOS, TX Holiday • Deveraux's Oyster Bar, Palace • Southwest Texas Gold and Silver Exchange

WICKLY, PA Sewickly • The Nickelodeon Mall

HELBYVILLE, KY Burley • Fireside Antique Galleries, Shelby • Tracys Furniture Store

ODUS, NY Sodus • H&W Supplies / Hair Hut

OUTH BEND, IN Palace • Morris Civic Auditorium

. LOUIS, MO Beverly • Living Word Apostolic Church, Cinderella • Gateway Fitness Center, Fairy • Tubeless Tire Outlet, Varsity • Glaser

Drug Store, Virginia • Seed Faith Word Fellowship Church

STANTON, KY Stanton • Shepherd Printing

STATEN ISLAND, NY Empire • Farrell Lumber, Inc., Palace • Grimshaw Confectionary, Ritz • JoKai Karate / warehouse, St. George • Puerta de Paz television ministry, Staten • Costal Plumbing Supplies

SUPERIOR, WI Palace • Victory Fellowship Church, Princess • Frankie's Bar, Superior • East End Hardware

SWEET SPRINGS, MO Uptown • apartment building

TERRE HAUTE, IN Best • Wilden Talley Memorial Playhouse, Garfield • Banks of Wabash for Barbershop Chorus, Lyceum • Living Word Ministries, Swan • Shoes and Uniforms, Wabash • Scottish Rite of Free Masonry

TEXAS CITY, TX Jewel • Wexler's Furniture

THORP, WI Thorp • Coast-to-Coast Hardware

THREE LAKES, WI Three Lakes • Loonery (mini-mall)

TOLEDO, OH Lyric • Walter Funeral Building, Mystic • McCrarys Best Mart, Ohio • St. Hedwig Cultural Center, Princess • Taylor Photo, Tivoli • Our Lady of Fatima (Knights of Columbus)

TOLLESON, AZ Tolsun • Tolleson Funeral Parlor

TOMAH, WI Erwin • Cubby Hole Baseball Cards / storage for Band Box Cleaners

TONKAWA, OK Ray • Maverick Lanes

UNIONTOWN, KY Union • Hair Care Center

VANCEBURG, KY Kentucky • J. C. Video, Strand • Strand Recreation

VERNON, TX Vernon • Norsworthy Music Center

VICTORIA, TX Campus • Woodlawn Bowling Center, Victoria • Theatre Victoria (performing arts)

WABASH, IN Colonial • The Francis Shoppe (clothing)

WANTOMA, WI Park • Fox Valley Technical College

WASHINGTON COURT HOUSE, OH Fayette •

Police Athletic League, Palace • First Savings and Loan Association, State • Giovanni's Dining Room

WAUSEON, OH Princess • Osborne Drug Store

WELLINGTON, TX Texan • The Long Dollar (prom dresses, formal wear)

WHITEHALL, WI Pix • The Family's Inn (restaurant / supper club)

WHITING, IN Capitol • Sherman's Hardware

WICHITA FALLS, TX Roxy • Holmes Carpet Service

WILLCOX, AZ Willcox • Rex Allen's Arizona Cowboy Museum

WOODSBORO, TX Arcadia • The Fashion Shop / The Beauty Shop

WOODVILLE, OH Limelite • Temple Furniture

YOAKUM, TX Ritz • The Card Shoppe

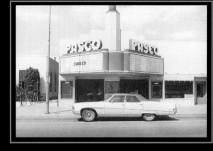

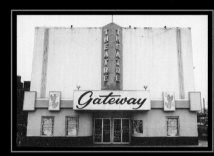

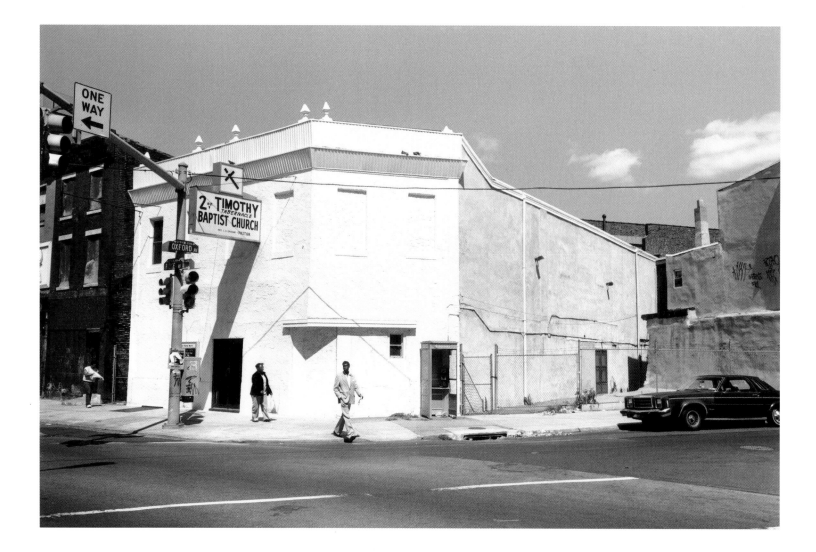

70

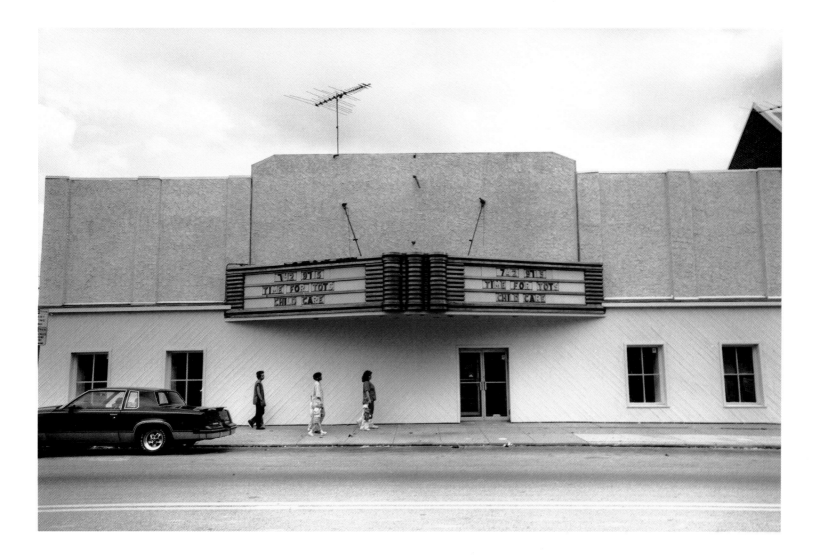

LAWNDALE, PHILADELPHIA, PENNSYLVANIA, 1988

71

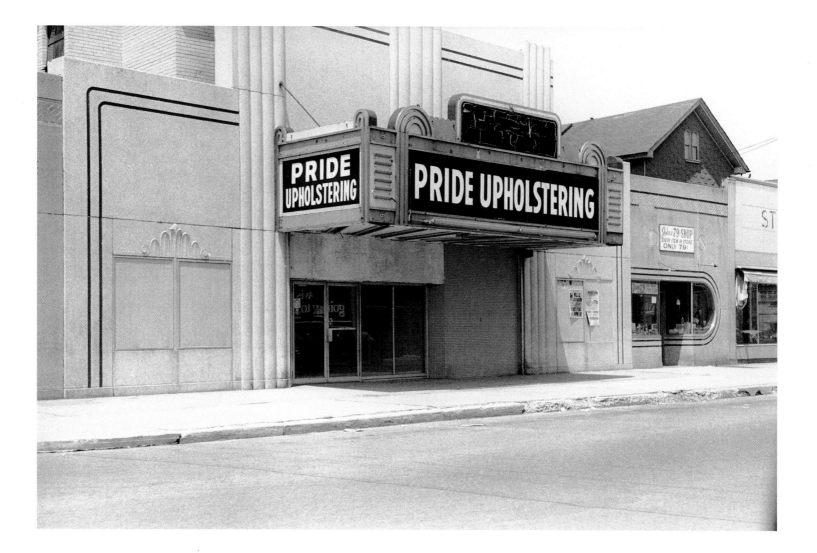

DIXWELL PLAYHOUSE, NEW HAVEN, CONNECTICUT, 1975

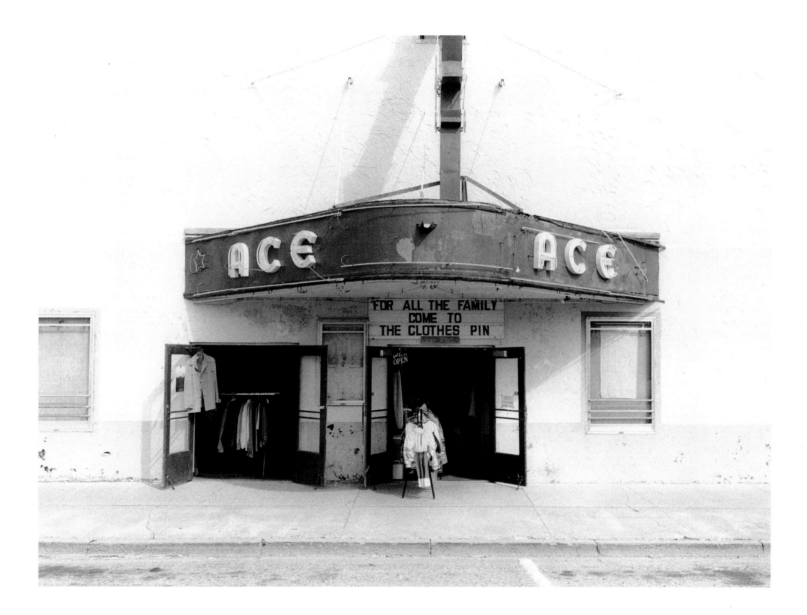

ACE, WENDELL, IDAHO, 1985

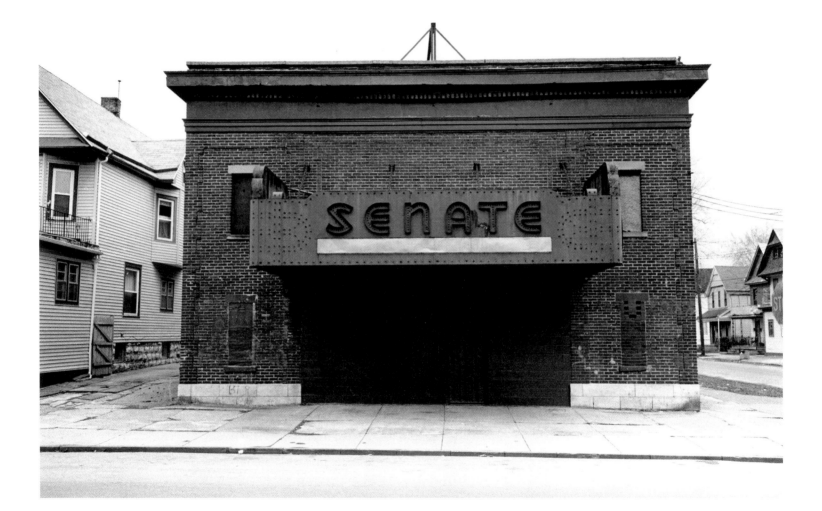

SENATE, BUFFALO, NEW YORK, 1995

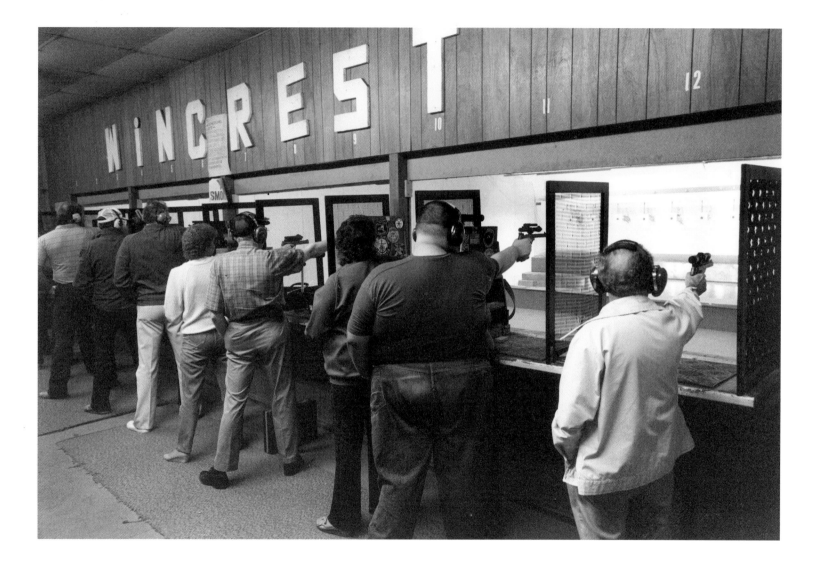

SENATE, BUFFALO, NEW YORK, 1986

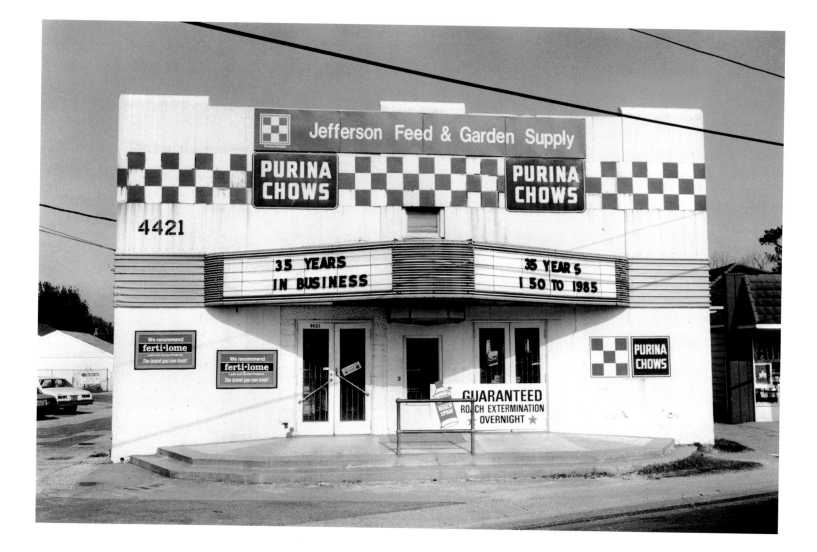

JEFFERSON, NEW ORLEANS, LOUISIANA, 1985

The twentieth century saw the rise, fall, and, ultimately, the selective reincarnation of small-town and neighborhood movie theaters in America. The rise began in the years before the First World War, when motion-picture houses began to take root not only in city centers but along small-town main streets and in the hundreds of neighborhood shopping districts springing up beside electric-streetcar routes that radiated out of central business districts, from Boston, New York, and Chicago to Atlanta, Denver, and Los Angeles.

More than simply another business along the sidewalk, the new houses of entertainment, for the most part, visually upstaged their more staid commercial neighbors. In fact, by the 1920s, the iconic force of the movie house had become so powerful in the public mind that the brightly lit marquee, touting the latest movie playing in town, became a sure sign that a main street or neighborhood shopping area had "made it."

Then came the great American commercial diaspora that began after the Second World War and continues today at breakneck speed. Spurred on by the decentralizing influence of the automobile, local neighborhood and main-street services (including the movie theater) migrated to the edges of town and beyond, where food stores metamorphosed into mega supermarkets, variety and dry goods stores into Kmarts and Wal-Marts, and motion-picture theaters into multiplexes, all surrounded by acres of parking. As for the fate of the older motion-picture theaters that remained downtown in the age of sprawl (and television), a few survive, but the others have been abandoned, demolished, or refurbished for other purposes.

The luckiest theaters, in terms of original intent, are those that have been restored and only slightly modified to become, for example, performing arts and cultural centers as part of historic preservation and civic efforts to revive older

SILENT SCREENS IN A NEW CENTURY

Chester H. Liebs

commercial areas. Some movie theaters have been put to reasonably compatible new uses that have kept them substantially intact, most notably as churches. With their ample seating for large congregations, with screen stages easily convertible to alters and choir platforms, with marquees trumpeting biblical passages to passersby, and with locations easily accessible to parishioners in surrounding neighborhoods, thousands of former houses of entertainment have been born again as places of worship. Other entrepreneurs have viewed the movie house as merely a large and available volume of cheap commercial space. Rather than the theater's greatest structural asset—a public auditorium—being used to advantage, the seats have been torn out, the interiors gutted, and the movie houses recycled into everything from bowling alleys, swimming pools, and shooting ranges to restaurants, day-care centers, and feed and grain stores.

With each passing year, more old-time movie houses are abandoned or demolished. But those that do survive will no doubt continue to be rediscovered and reclaimed, compelling future generations to remember what the silver screen meant to an America on the move.

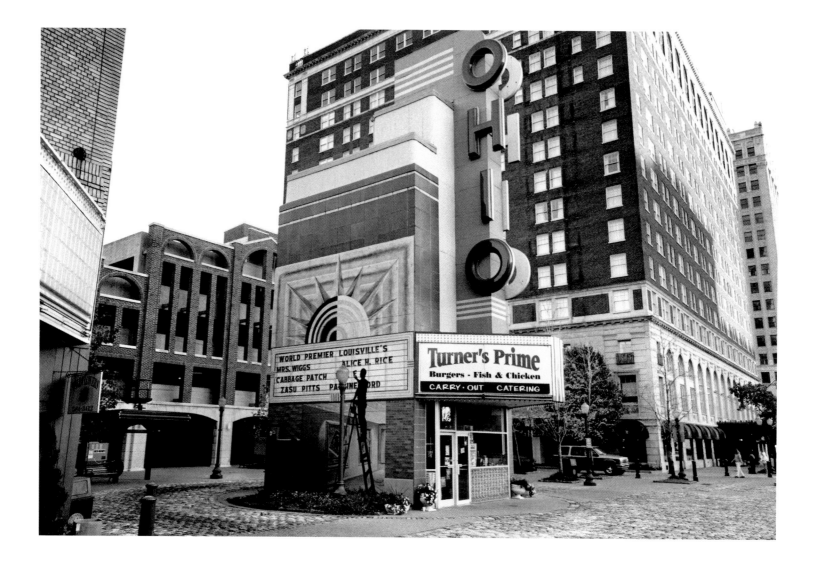

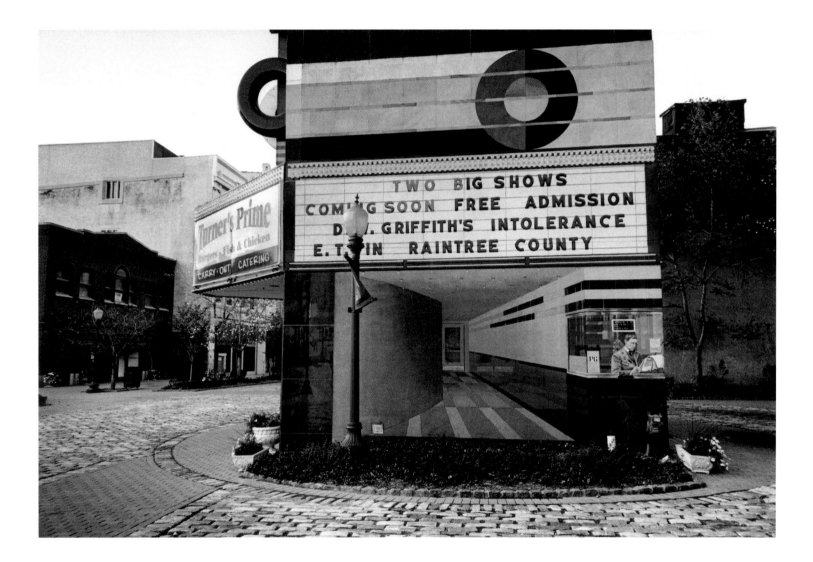

OHIO, LOUISVILLE, KENTUCKY, 1995

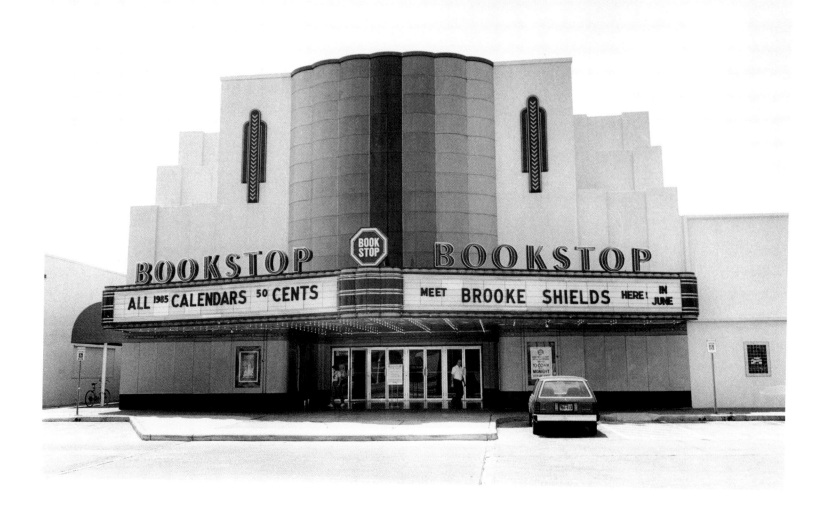

ALABAMA, HOUSTON, TEXAS, 1985

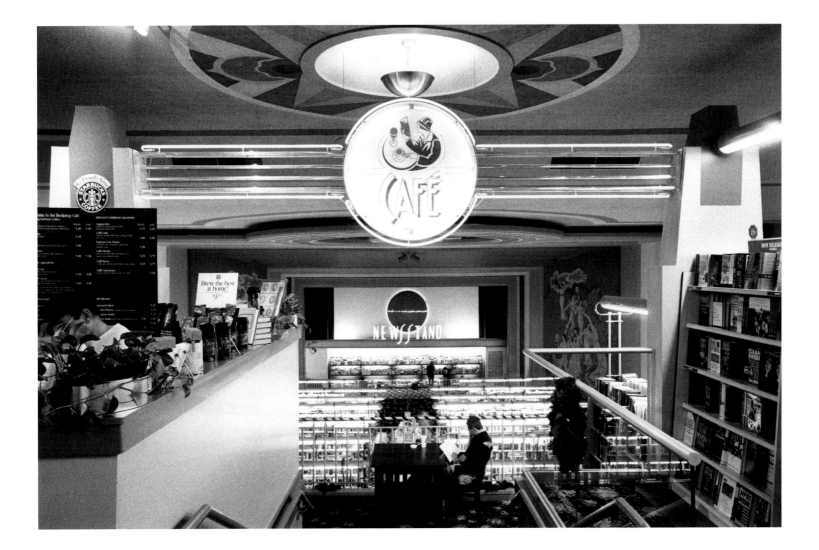

ALABAMA, HOUSTON, TEXAS, 1995

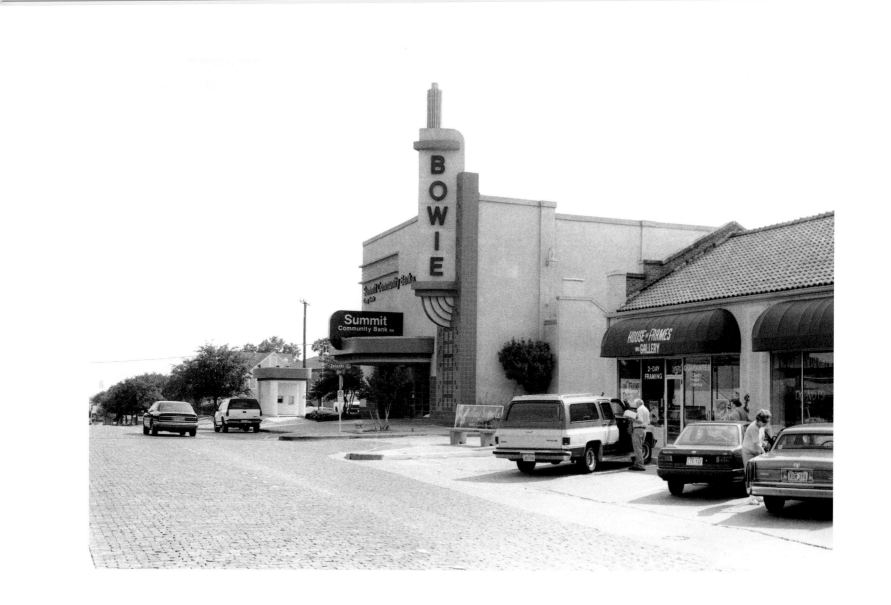

BOWIE, FORT WORTH, TEXAS, 1998

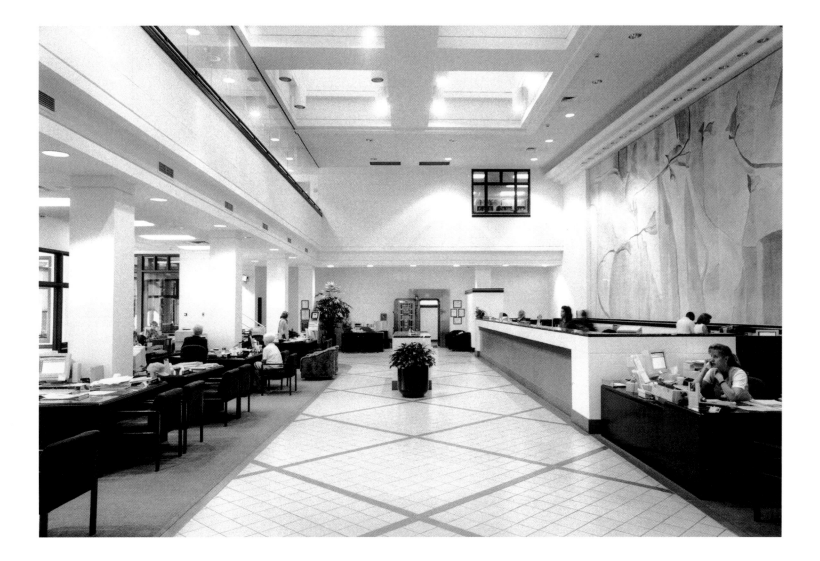

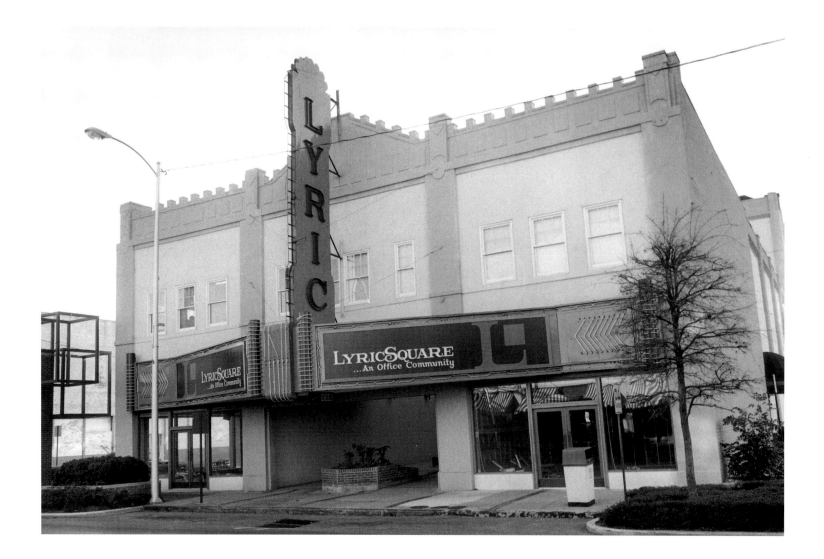

LYRIC, ANNISTON, ALABAMA, 1985

CRESCENT, LOUISVILLE, KENTUCKY, 1995

CRESCENT, LOUISVILLE, KENTUCKY, 1995

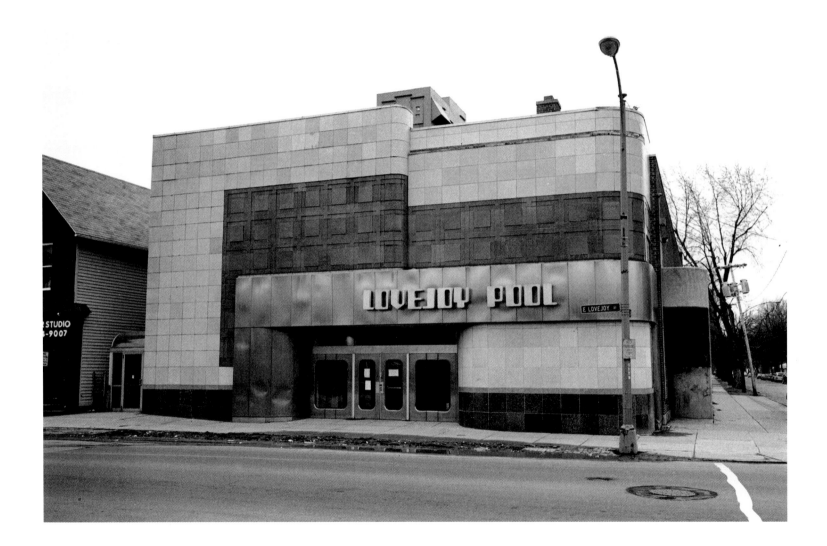

90

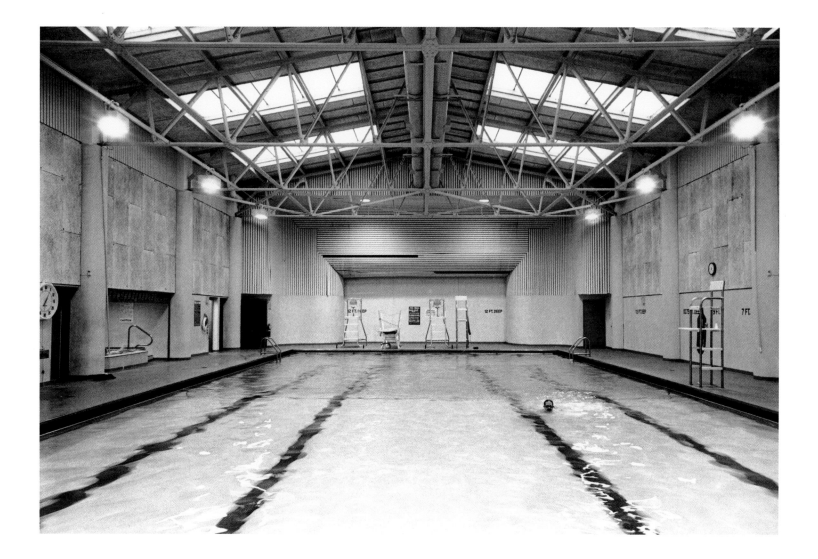

LOVEJOY, BUFFALO, NEW YORK, 1995

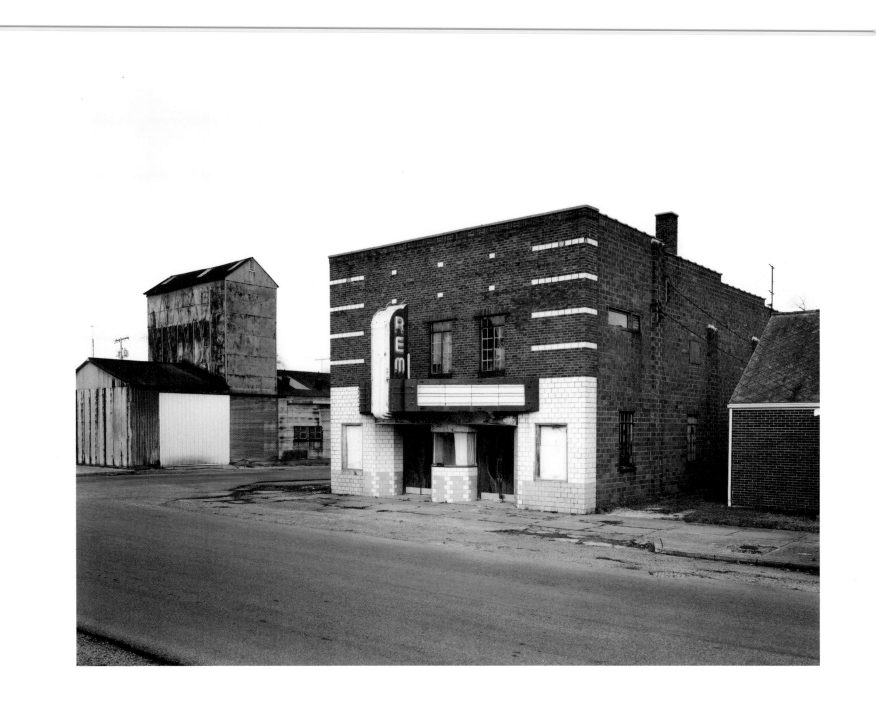

REM, REMINGTON, INDIANA, 1995

Honor them all. Remember how once their splendor blazed

In sparkling necklaces across America's blasted

Distances and deserts: think how, at night, the fastest

Train might stop for water somewhere, waiting, faced

Westward, in deepening dusk, till ruby illuminations

Of something different from Everything Here, Now, shine

Out from the local Bijou, truest gem, the most bright

Because the most believed in, staving off the night

Perhaps, for a while longer with its flickering light.

These fade. All fade, Let us honor them with our own fading sight.

JOHN HOLLANDER, from "Movie-Going"

This project began with Route 66. I photographed the road in the early 1970s—from the first sign on Michigan Avenue in Chicago to the plaque that signals the road's end at Santa Monica, California. I searched for the things that had been abandoned and covered over, for the artifacts, the representations of a lost civilization, and the right-of-ways that had been paved over or circumvented. It became clear to me too, as my Plymouth Sport Suburban pushed westward through Cicero, Lebanon, Galena, Claremore, Amarillo, Santa Rosa, San Bernardino, and Pasadena, that I had arrived barely in time. The silhouettes of black cats, the diving women, and the cutout waitresses were taking their last breaths. As for the road itself, it wove in and out of obscurity, running for miles under its own designation, then swallowed up by I-40, then reappearing as a two- or four-laner—again Route 66. And there was the secret road, the undetectable stretches—sometimes only patches—that ran through neighborhoods or parallel to the interstate, to be found only by word of mouth.

The traces interested me, and as I continued into the 1980s making cross-country trips, I found my material in the small towns and inner-city neighborhoods of America. By now I was photographing with equal enthusiasm the old and the new downtowns. Although the two often fused, I pursued them as separate considerations. I would seek out the old buildings and the small pockets of downtown areas where I might come across a detail—a doorway, a sign, a number—that reflected the life of a previous era. At the same time, I was photographing the spaces produced by urban renewal, especially the small, awkward, and often amusing parks—places to sit—which were being created in these spaces.

My instincts brought me to representations of the new American city, with its glass structures and atriums, its new spacial alignments, but my soul lay firmly

CONCLUSION

Michael Putnam

95

in the past. Out of longing, the downtown movie theater emerged as my subject. At first I did not distinguish the theater from the American town in general. I was drawn to photograph Main Streets, architecture, and public monuments. I often included the theater in my framing of a Main Street scene, without being aware of its immanent significance for me. But then, there were also certain theaters I was compelled to photograph, so strongly did they suggest to me the abandonment of the downtown areas.

It was an emotional response to a darkness I felt in these towns. The cultural and commercial shift from downtown to perimeter areas was draining their spirit. I saw the theaters I was drawn to photograph—closed theaters for the most part—as embodiments of the death of the American town.

When I began this project in earnest in the early 1980s, I had no trouble finding closed theaters. They were everywhere. I would enter a town, usually on a four-lane road which fed directly into Main Street and often passed the town square directly to its north. Look straight, look to the left, circle the square. Where is it? Will I be able to recognize the building? Will the marquee still be up? Usually I would see the theater right away. Its importance to community activities had assured it a place of prominence. Even if it had been stripped of the motifs so often associated with its function, the shape of the building often gave it away. When I could find no trace of the theater and knew that the town must have had one, I would look for the barbershop. The barbers had the information I needed and more. They knew everything about their town's history and felt a compulsion to speak about it. Their shops were often next to movie theaters. Grooming was an important part of the Saturday visit to town. The drugstore was the next best bet for information about the local theaters and might even be relied upon for leads to other theaters within the county.

As the years passed, and the commercial strips of franchises became the new Main Streets, I would have to find the old downtown—at this point usually known as the "historic district"—before I could locate the site of the theater. "What are you looking for?" was the usual response to my question, from the teenager working at the gasoline mart, who usually didn't know of a movie theater in the original town and for whom the word *downtown* carried a different meaning than it did for me. If I could find someone over the age of 50, I could usually get the information I needed. Failing that, if I asked for the old post office, and there still was one, I might find my way downtown that way. Often, I would simply look for the water tower and feel my way.

During the early field trips, I photographed the theater as I found it. I was not discouraged by having to photograph into the light, nor was I deterred by a parked car in front of the theater. In fact, accepting the conditions given me seemed to lend its own effect to the photograph. As the project evolved into the 1980s, I altered my technical approach. I began to work with different formats in an effort to see the theater in a new way. The 8 x 10 view camera forced me to address the issues of light and composition with greater care, to seek an image that brought the viewer closer to the tactile potential of a photograph. I was now concerned with describing the facade of the theater with the greatest clarity possible, and vehicles and people became distractions.

To execute these refinements in the picture-making process, I had to practice both a patience and a quickness that I had rarely called on before. I had to coax people into moving their cars, I had to set up the view camera before the light disappeared, and I had to wait for the clouds to make the right moves. The view camera is both a piece of technical equipment on a tripod and an object of curiosity, comment, and perhaps even mythology, in any public space in which it is set up. The view camera creates an event.

While my photographs were being altered by the technical adjustments I was making, the methodology I was using to find the theaters had also changed. I had discovered the *Film Daily Yearbook* for 1952, which, in addition to summarizing the activities of the film industry for the year, listed all the existing movie theaters in the country. The *Yearbook* listed every town that had a theater in 1952 alphabetically by state, and it listed in alphabetical order every theater in each of these towns. Often in the case of larger towns or cities, where there might be many theaters, the *Yearbook* gave addresses.

Having the list gave me a mixed sense of satisfaction and doubt. It simplified my life on the road, but what if it compromised the romance of travel, the mystery and excitement of entering a town not knowing what I might find? Because of the list, I became more systematic in planning my trips. I would circle on maps the names of towns with theaters; I chose routes that would pass through as many of these towns as possible; I made lists of theaters in cities, arranged geographically, and I marked on city maps the streets where theaters stood— or had stood. As I became more involved in accounting for as many theaters as possible, I intensified my search for them. I became a collector of images.

In small towns where I knew there was a theater, it was a simple matter to find the structure. When the towns were larger, or when I was in cities, the list took me away from the downtown into surrounding neighborhoods, where I would see the theater in a new context. The list allowed me to see areas where I normally might not have been welcome. The project gave me the license to be there, and the inhabitants were always interested.

Although I continued to be drawn to photographing theaters that were closed, decayed, and neglected, I also became interested in photographing the sites where theaters had once stood and in a more recent phenomenon: theater

buildings that had been converted into other businesses and enterprises. It seemed important to comment on what American society had transformed the movie houses into and to speculate on how this reflected current social priorities. As to the sites, they were often disturbing in their emptiness. I was witness to a continuum in which the landmarks existed only internally.

In Santa Rita, New Mexico, such lamentations for the past were hardly possible, so complete was the devastation. The entire town was now an open copper-mining pit. As I stood at the rim, tiny trucks wove their way along the spiral highway down to the base of the mine. Gone was a community. Gone were the hospital, the school, the houses; gone was Main Street, and with it the El Cobre Theater.

In 1985 it was still possible to find many small-town theaters intact—usually closed but with marquees and names in place. The frayed exteriors scarcely concealed a deeper malaise that had overtaken the theater's interior. Approaching the front, I might be able to look through the door panes into an auditorium that surrendered its darkness to shafts of sunlight coming through a decaying ceiling. On occasion I was able to slip in through a partly open door, as I did in Big Stone Gap, Virginia, on Sunday, November 10, 1985. I was given the chance to witness this theater's last moment. I stood for a long time in the damp silence, looking over disheveled rows of theater seats, and then I found an old ladder and climbed to the balcony, where I could overlook the theater. It was painful to lift the camera to my eye to photograph the ruin I could feel and smell. But time had somehow been suspended long enough for me to record it, and I did so as if under obligation. Later in the same trip, in northwestern Texas, I was in the process of photographing the interior of another abandoned theater when two demolition workers arrived to take down the ceiling. They

gave me twenty minutes to do my work before beginning to do their own. Time was clearly on their side.

For a while I believed the theaters would always be there, waiting for me to photograph them. But by the end of 1989 I realized that my subject was disappearing. Long trips proved less fruitful. Instead of the small lovely theaters I dreamed of, I saw more and more conversions. Or nothing. With some exceptions in capital cities and university towns, the movie theater had vanished. The movie theater, the downtown hotel by the railroad tracks, the individual storefronts, the unique signs—the spirit of place that is seen in its physical properties—all this was being replaced by a more homogeneous American town that looked static and repetitious to me.

A new way of life had been in motion for many years. Finding and photographing movie theaters was, for me, inseparable from the experience of being on the road, just as the past is inseparable from whatever I am photographing.

We live in our own era, and we see the present from the point of view of that era. With modern eyes I would see the superhighway at its intersections with the past. I would see the corporate multiplex theaters of mall and city as the picture houses and palaces of today. I would see the uniformity of sign, shape, and slogan as the architecture of expectation, as I do the small-town Main Street of my own era.

The past has different aspects, depending on one's place in relation to it. The present generation will see these photographs as representations of history. For me they are reflections of experience.

ANDREW SARRIS is the film critic of the *New York Observer* and is the author of numerous books on American directors including *American Film Directors, The Films of Josef von Sternberg,* and *The John Ford Movie Mystery*. His most recent book is *"You Ain't Heard Nothin' Yet": The American Talking Film: History and Memory, 1927–1949*.

ROBERT SKLAR is the author of *Movie-Made America : A Cultural History of American Movies* and *Film: An International History of the Medium*. He is a professor of cinema studies at New York University.

PETER BOGDANOVICH is the director of *The Last Picture Show, Texasville*, and other films, and he is the author of books on Orson Welles and John Ford. His most recent book is *Who the Devil Made It*, conversations with American film directors.

MOLLY HASKELL is the author of *From Reverence to Rape: The Treatment of Women in the Movies* and *Holding My Own in No Man's Land*. She has been the staff critic for the *Village Voice, New York Magazine*, and *Vogue*. Her work appears frequently in the *New York Times*, the *New York Review of Books*, the *Nation*, and other publications.

JOHN HOLLANDER is a poet and critic. He is the author of *Movie-Going and Other Poems*, among many other volumes of poetry, and of four critical texts, including *The Figure of Echo*. He is the A. Bartlett Giamatti Professor of English at Yale University.

CHESTER H. LIEBS is the author of *Main Street to Miracle Mile: American Roadside Architecture*. He is a professor emeritus of history and founding director of the Historic Preservation Program at the University of Vermont, and he is currently a public-radio commentator and coordinator of professional exchanges between the United States and Japan.

LARRY MCMURTRY is the author of *The Last Picture Show* and many other novels and screenplays. His most recent book is *Duane's Depressed*.

CONTRIBUTORS

Michael Putnam was born in New York City in 1937. He has worked as a photographer for the Pepsi-Cola Company, and he also spent a year as an official photographer for the Mexican government during the Cultural and Sports Olympics of 1968. In 1970–71, Mr. Putnam photographed family life in Tokyo, Moscow, and London for the Cities Project, Cambridge, Massachusetts. He has photographed daily life and customs along the Ganges in India over a twenty-year period. Since 1975, he has traveled extensively in the continental United States, producing an essay on Route 66 and documenting everyday life in small towns and urban areas. Mr. Putnam served as one of the principal photographers for the National Road project in 1995. His photographs have been published in *America Illustrated, Creative Camera, Du, Harpers Weekly,* and *U.S. Camera,* among others, and his film on a burlesque dancer in San Francisco, *Hard Swing* (1960), received the Best Film Award at the Charles Theater Film Festival in New York City.

Alligators, Prehistoric Presence in the American Landscape
Martha A. Strawn, with essays by LeRoy Overstreet, Jane Gibson,
and J. Whitfield Gibbons

Belonging to the West
Eric Paddock

Bravo 20: The Bombing of the American West
Richard Misrach, with Myriam Weisang Misrach

Disarming the Prairie
Terry Evans, with an introductory essay by Tony Hiss

Invisible New York: The Hidden Infrastructure of the City
Stanley Greenberg, with an introductory essay by Thomas H. Garver

Measure of Emptiness: Grain Elevators in the American Landscape
Frank Gohlke, with a concluding essay by John C. Hudson

The New American Village
Bob Thall

Nuclear Landscapes
Peter Goin

The Perfect City
Bob Thall, with an essay by Peter Bacon Hales

**OTHER BOOKS OF
PHOTOGRAPHY
IN THE SERIES**

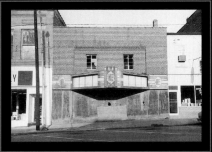

SILENT SCREENS